Simple
Beautiful
Food

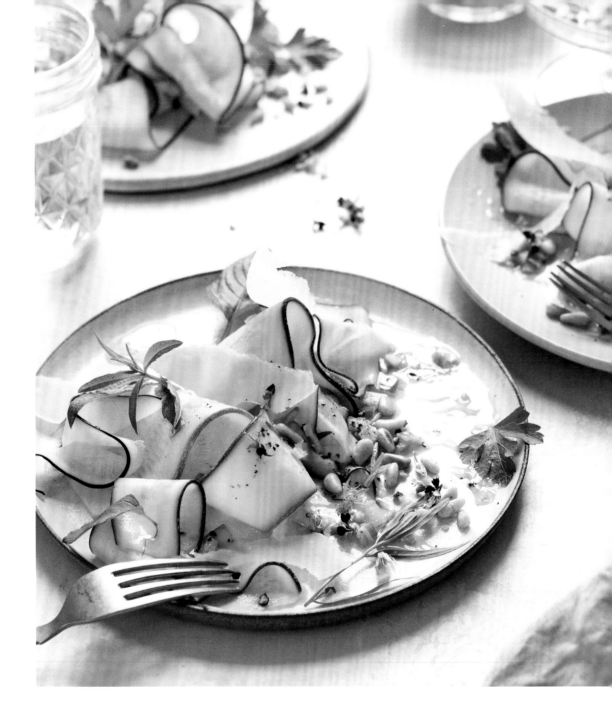

AMANDA FREDERICKSON

Simple Beautiful Food

Recipes and Riffs
for Everyday Cooking

TEN SPEED PRESS
California | New York

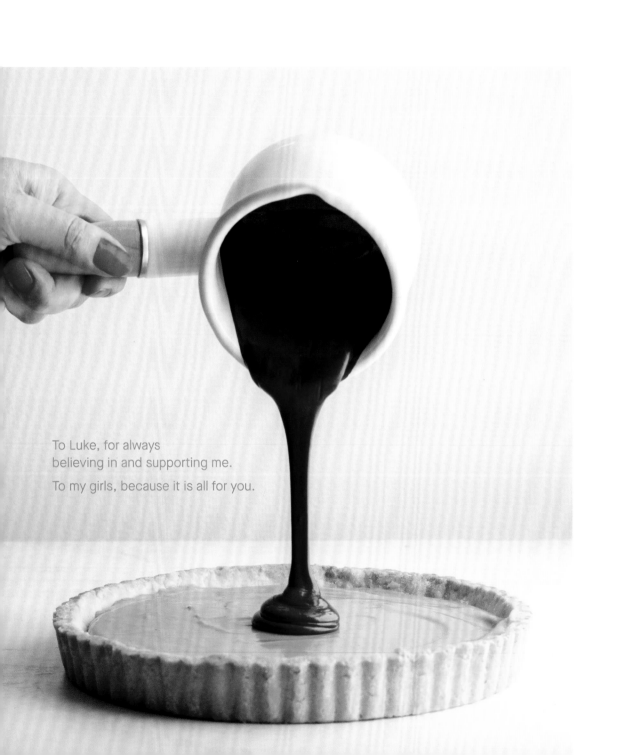

To Luke, for always
believing in and supporting me.

To my girls, because it is all for you.

Contents

Welcome!

Thank you for buying this book; I'm thrilled for you to discover and cook your way through some of my favorite recipes. My promise to you is that the effort of making these dishes will be more than worth it, because the 100-plus recipes in this book are easy to follow and delicious to eat.

When I set out to write this book, I was inspired by what food has become in our modern world. We eat with our eyes. We all love to look at food that makes us stop in our tracks when we see it—food that oozes style and texture and, most of all, makes us want to dive right in.

Unfortunately, often when trying to create the perfect picture-worthy dish, we focus on style at the expense of taste. We all love gorgeous food, but let's make gorgeous food that is easy to create with ingredients that are simple to source and taste as amazing as they look. Let's create food that is nourishing and delicious enough to share with friends and family.

In this cookbook you will find recipes that are uncomplicated. All of the recipes were developed for taste, ease of use, and how gorgeous they will look when plated. I promise that you will never have to go to five different grocery stores to source the ingredients in this book; they can be found at your local grocery. If something is super seasonal or might not be found at your grocery store, I will always give easy alternatives.

I have included a chapter at the end of the book called Flavor Gold. These recipes are easy ways to take your dish from great to amazing. Flavor Gold includes my pickled red onions, which add just the right amount of tanginess to a dish, and my preserved lemons, which add a salty citrus flavor. Check out the chapter and feel free to mix and match. Flavor Gold recipes all store easily in your fridge so you can always add a sprinkle, dollop, or spoonful and take your dish to the next level.

I pared down these recipes so they would appear in their simplest form. There are no headnotes, and I included the ingredient type and amounts in the method (**bolded**) to make them simple and straightforward. I'm hoping an image will catch your eye and that you can quickly read through the recipe

and decide to commit. The methods are also simplified to save you time reading and get you cooking as soon as possible. Scattered throughout the book are tips and tricks for becoming a better cook, as well as a riffs on one ingredient that is taken through many different ways of preparing it. These sections will allow you to explore recipes and ingredients to come up with your own simple beautiful food.

In case you are new to my food world, here is my food and cooking philosophy: I believe in simple, straightforward cooking. I try to use as few pots and pans as possible because we all have better things to do than spend hours washing dishes. These recipes will empower you to cook more often while spending time enjoying the food you make with friends, family, or just yourself. I believe that half of cooking is having the confidence to get in the kitchen and get started. You can see this philosophy in my Fridge Foraging series on Instagram, where I make simple meals from what I have on hand.

My philosophy is judgment-free. We all feel the pressure to buy everything organic, free range, local, sustainable, and non-GMO. I agree with all of those things, and I would love to be able to say that I cook only with organic, free-range, local, sustainable, and non-GMO ingredients, but that would be a lie. Like many people, I can't realistically afford to buy everything organic and sometimes I don't have access to only local ingredients. Times are changing, and I hope one day this type of food is available to everyone, but until then I pick and choose my battles. My onions may not always be organic, but any sort of meat or animal product that I buy is always organic and free range because I am passionate about animal welfare. So start with one part of the equation that resonates with you (non-GMO, organic, animal welfare) and don't feel judged if you can't do it all. Start small and do what you can.

In my opinion, getting into the kitchen is half the battle of a healthy lifestyle. If you are making your family a fresh homemade meal that doesn't have a ton of processed ingredients, then you are halfway there.

All of this is to say: Keep it simple. This should be fun, creative, and stress-free. So let's dig on in, get a little messy, and get cooking.

Pantry Staples

Here are some staples in my pantry that I can't live without. These are not only kitchen basics but items that will make your food stand out. Notice this list is not long, but these flavor boosters can change almost any ingredient into something spectacular. Salt, oil, and acid are the building blocks of flavor, and all three are needed to create a balanced dish; herbs are essential for adding richness and depth and are a simple way to elevate any dish.

ACID

Acid comes in many different forms, such as lemon juice, white wine vinegar, red wine vinegar, and sherry vinegar. Acid helps balance dishes and makes food taste bright and lively. I always try to at least have lemons or vinegar in the kitchen. Acid will cut through any heaviness in a dish and make it taste more delicious.

FRESH HERBS

Fresh herbs are some of the most important ingredients in my kitchen, and there are few dishes that don't benefit from their addition. They are the basis for my Goes-with-Everything Herby Green Sauce on page 219, and I love the Arctic char dish on page 169 where the fish is roasted and topped with mounds of fresh herbs. Fresh herbs pack a ton of punch without much effort, and I add them to salads, soups, grain bowls, roasts, and more for extra flavor, color, and texture. I especially like to use soft-stemmed herbs like parsley, cilantro, basil, dill, tarragon, and chives. These soft herbs (unlike hard herbs like rosemary and oregano that have woody stems) require no cooking time and can be easily added to just about any dish without too much preparation. They are always on my grocery list and a staple in my fridge.

OILS

Some of my favorite oils are olive oil, grapeseed oil, hazelnut oil, walnut oil, and coconut oil. Oil makes food taste more satisfying and filling, and it can be used to layer in flavor as well. Use neutral oils like vegetable oil or grapeseed oil when no extra flavor is needed, or add flavor with hazelnut, olive, coconut, and walnut oils. Oils have different smoking points, so some are better for cooking than others. I use olive oil the most in my everyday cooking. Personally, I love California olive oil; I look for options that are affordable and tasty so that I can use the same olive oil not only to cook and sauté with, but also as a finishing drizzle. In addition to olive oil, neutral oil, and coconut oil for cooking, I use specialty oils like unrefined hazelnut or walnut oil as finishing oils when a little extra flavor is needed. You can find all of these oils at regular grocery stores, and I even spotted hazelnut oil and walnut oil recently at Target. They can be expensive, but a little goes a long way.

SALT

I can't stress enough the importance of salt; it's an essential ingredient that intensifies flavor and makes simple food taste amazing. All of the recipes in the book were developed with kosher salt. I only use kosher salt because unlike regular table salt or iodized salt, it doesn't have iodine it in, which has the tendency to create an unwelcome aftertaste. Also the salt crystals in kosher salt are bigger, allowing you to season a dish more gradually since a larger crystal doesn't dissolve as quickly as the small crystals found in table salt. I am also a huge fan of finishing a dish with a sprinkling of flaky sea salt, like Maldon or Jacobsen salt, and even have an array of flavored salts like vanilla salt and habanero salt that add a little extra something and are perfect for a little experimentation.

Shopping List

I get asked all the time about what I buy at the grocery store. Why? Because I'm usually able to pull a quick and easy meal from my pantry with little planning. Here are my must-haves that I stock (and restock) in my fridge and pantry on a regular basis; they are great building blocks for creating a dynamite meal on the fly.

Speaking of shopping lists, the ones in this book are organized by how you would shop at the grocery, with like ingredients (dairy, produce, spices) appearing together. I assume that you have salt and pepper at home—even flaky salt—so those ingredients will not appear on the lists.

BEANS

I like all types of beans, but I always seem to grab the chickpeas and cannellini beans. Canned beans are a little easier, but dried beans are great when you have the time. Beans are an amazingly simple and healthy way to make a hearty meal; pick your favorite and stock up. One of my favorite recipes in the book is the Bacon, Beans, and Greens over Toast on page 158 and is a great example to why you should always have a can of beans hanging around.

BREAD

Bread, such as a country white or sourdough, is kind of like eggs: if you have some on hand, there are endless possibilities for what you can make. See page 125 for my favorite riffs on this pantry staple.

CHICKEN THIGHS

If you can buy only one cut of meat at the grocery store, always go for the chicken thighs. They are the most flavorful and succulent part of the chicken and will be one of the more cost-effective cuts since the butcher doesn't have to debone or remove the skin. Check out some different combos for chicken thighs on page 155.

EGGS

If you have eggs in your fridge, you are halfway to a meal. They are a staple not just for breakfast, but for any and all meals. More ideas for what to do with eggs are on page 21.

GRAINS

Pasta, rice, and quinoa are always stocked in my pantry because they make a great base for so many quick dishes. I think of them as blank slates you can add so much flavor to with different proteins, veggies, herbs, and oils. Check out page 77 for some inspiration.

GREENS

Any type of leafy green will do. Swiss chard and lacinato kale are my go-tos, but spinach works, too. You can make a salad with these, sauté them and top with a fried egg, or even make a hearty baked egg dish with all the leftover vegetables in your fridge. Plus, they are healthy!

MISCELLANEOUS PANTRY ITEMS

In addition to the ingredients listed above, I make sure I always have the following staple ingredients on hand and use them throughout this book. For all recipes that call for flour or butter, I use all-purpose flour and unsalted butter. I use salted butter only when serving something like fresh bread and prefer unsalted butter for cooking because you can add salt to the recipe, but you can't remove it.

Kitchen Tools

Don't let anyone tell you that you need a fully outfitted kitchen to be a good cook. All you need are a couple of simple pieces and the rest is just extra credit. Here are the tools that I rely on the most in my day-to-day cooking.

CAST-IRON DUTCH OVEN AND SKILLET

I am a huge fan of cast iron, and both a Dutch oven and skillet are two of the most-used pans in the kitchen. I like enameled cast-iron pans because cooking in them is so much easier than the ones that aren't enameled; non-enameled cast iron must be well-seasoned so that delicate ingredients like eggs don't stick to them. They are investment pieces and their versatility and durability makes them 100 percent worth it. Check out sites like eBay or Craigslist for lightly used enameled cast-iron pans at a discounted price.

NONSTICK PAN

Every kitchen needs at least one nonstick skillet, which is perfect for delicate dishes like eggs and fish.

FOOD PROCESSOR AND A BLENDER

These are not absolutely necessary but will make your cooking a little easier and help you to make the Tropical Mango and Coconut Smoothie Bowl (page 22), The Perfect Pie Dough (page 211), and White Chocolate Ice Cream with Roasted Strawberry (page 198).

STAND MIXER OR HAND MIXER

I use a stand mixer for baking. It makes tasks like creaming butter or whipping egg whites that much easier. If you don't have a stand mixer, you can usually use a hand mixer instead. Stand mixers are an investment but it's possible to find gently used ones on websites like Craigslist or eBay.

CHEF'S KNIFE AND PARING KNIFE

My most-used knife in the kitchen is a 10-inch chef's knife. I use it for almost everything. I also have a paring knife for jobs like cutting strawberries and cutting out citrus segments. You will use these knives over and over in the kitchen and don't need more than them.

MANDOLINE

A mandoline makes cutting and slicing so much easier and exponentially quicker than using a knife. It can get slices of vegetables super thin so they will look made by a fancy food–styling pro. Word of warning: Please be careful. Those blades on the mandoline are sharp. My favorite brand is one of the most affordable: Benriner, from Japan.

MEAT THERMOMETER

The key to mastering cooking meat, especially chicken, is using a meat thermometer. With a thermometer, there is no need to guess if a piece of chicken is done. Digital ones are great, but they can be expensive; there are some really great analog ones out on the market as well. Also, don't tell anyone, but I use my meat thermometer when I am making sweet dishes, too. It works just fine when I am making Homemade Ricotta (page 30) and the Millionaire's Tart on page 201. Plus it is one less thing to buy.

RECIPES

TO

START

YOUR DAY

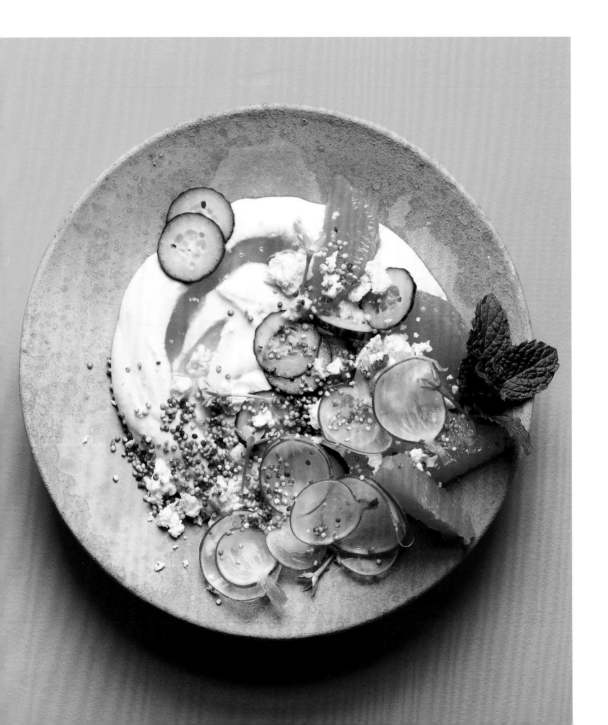

Sweet and Savory Yogurt Bowl

Bright, Creamy, Satisfying

SHOPPING LIST

Quinoa
Coconut oil
Olive oil
Apricot or fig jam
Cucumber
Radishes
Oranges
Fresh mint
Greek yogurt
Feta cheese
Naan or pita bread
(optional)

SERVES 4

Warm **2 tablespoons of coconut oil** in a large pot over medium heat. Add **¼ cup of quinoa** and stir well until the quinoa begins to pop. Place a lid on the pot and set aside.

Divide **2 cups of full-fat plain Greek yogurt, ½ cup of crumbled feta cheese, ½ thinly sliced cucumber, 4 halved radishes, 4 tablespoons of apricot or fig jam**, and **2 peeled and sliced oranges** among four bowls. Drizzle each bowl with a little **olive oil** and top with **fresh mint** and some **popped quinoa.** Serve with **naan** or **pita bread**.

TIP Use any combination of fruit and vegetables to create the satisfyingly sweet and savory aspects of this dish.

Overnight Oats with Apples and Toasted Walnuts

Creamy, Hearty, Sweet

SERVES 1

In a glass jar, combine **½ cup of old-fashioned rolled oats** with **½ cup of milk (dairy or almond), a pinch of salt**, and **½ teaspoon of ground cinnamon**. Place the lid on the jar and shake well. Refrigerate for at least 4 hours, or overnight.

When you are ready to eat, make the topping. Warm **2 teaspoons of coconut oil** in a skillet over medium heat. Add **½ peeled and diced apple** and sauté for 2 to 3 minutes. Add **½ teaspoon of ground cinnamon, ¼ cup of chopped walnuts**, and **a drizzle of maple syrup**. Continue cooking for 2 minutes, until the walnuts and apples are coated with maple syrup. Spoon the warm topping over the chilled overnight oats and eat.

TIP Consider doubling or even tripling this recipe for a couple days' worth of easy weekday breakfasts.

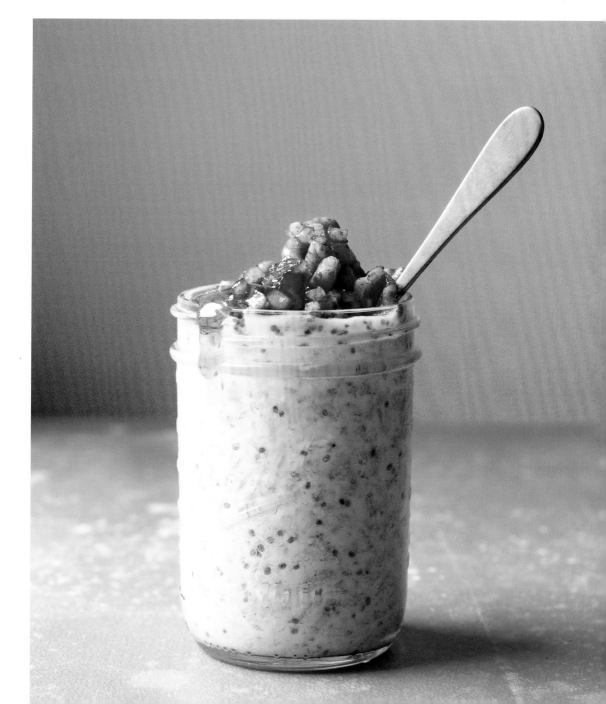

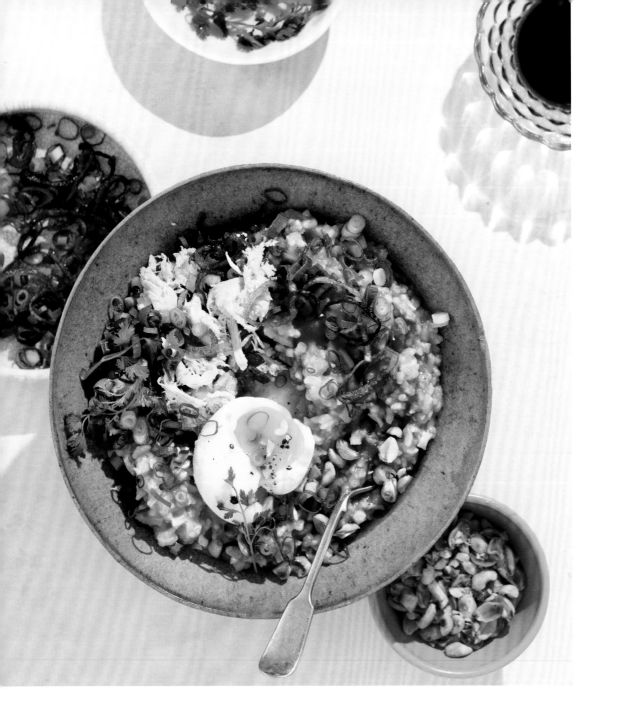

Savory Porridge Bowl

Creamy, Hearty, Savory

SHOPPING LIST

Jasmine rice

Stock

Peanuts (optional)

Toasted sesame oil (optional)

Soy sauce (optional)

Hot sauce (optional)

Shallots (optional)

Scallions (optional)

Cilantro (optional)

Egg (optional)

Cooked chicken (optional)

SERVES ABOUT 4

In a large pot, bring **1 cup of jasmine rice**, **7 cups of vegetable or chicken stock**, and **a large pinch of salt** to a boil. Turn the heat to low, and simmer uncovered for 35 to 40 minutes, until the rice is soft and creamy, the mixture has the consistency of oatmeal, and there is still a bit of broth that has not been absorbed. Taste for **salt** and **pepper.**

Ladle a scoop of the porridge into each bowl, top with your choice of toppings, such as a **6-minute jammy egg** (page 219), **crispy fried shallots**, **sliced scallions**, **soy sauce**, **hot sauce**, **chopped cilantro**, **peanuts**, **shredded cooked chicken**, and **toasted sesame oil**, and serve.

SHOPPING LIST

Pecan halves

Pumpkin seeds

Sunflower seeds

Rolled oats

Maple syrup

Vanilla extract

Almond extract

Coconut oil

Pitted dates

Yogurt or milk
(optional)

Fruit (optional)

Seeded Granola with Dates and Pecans

Crunchy, Sweet, Fragrant

MAKES ABOUT 4 CUPS

Preheat the oven to 325°F. Line a sheet pan with parchment paper.

In a small bowl, combine **½ cup of maple syrup**, **1 tablespoon of vanilla extract**, **1 teaspoon of almond extract**, **½ teaspoon of salt**, and **½ cup of melted coconut oil**.

In a large bowl, combine **5 cups of old-fashioned rolled oats**, **1½ cups of pecan halves**, **1 cup of pumpkin seeds**, **1 cup of sunflower seeds**, and **1 cup of coarsely chopped pitted dates**. Pour the maple syrup mixture over the oat mixture and mix well to combine.

Transfer to the prepared sheet pan and using an offset spatula, press the mixture evenly into the pan. Bake for 35 minutes. Remove from the oven and allow to cool for 1 hour. Break up the granola into bite-size pieces and either serve with **yogurt** or **milk** and **fresh fruit** or store in an airtight container until you are ready to eat.

TIP The granola will last for at least 2 weeks in an airtight container stored at room temperature.

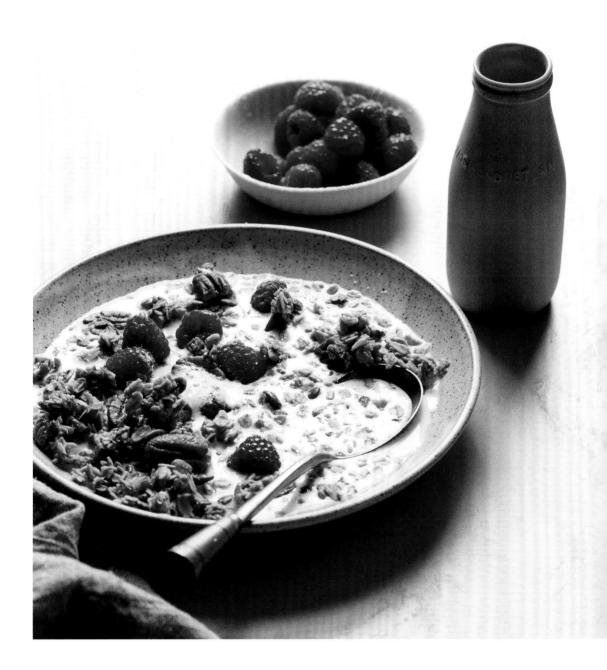

Riffs on Eggs

One ingredient infinite ways.

→ **SCRAMBLE** with **a little cream**, then fold in **caramelized onions** (page 227).

→ **SAUTÉ 1 bunch of leafy greens** and **a diced onion**. Add tomatoes and **a can of drained chickpeas**. Top with **a couple of eggs** and bake for 10 to 12 minutes in a 425°F oven, until the eggs are perfectly cooked to your liking.

→ **POACH an egg** by cracking it into a pot of just barely boiling water that has **1 tablespoon of white vinegar** in it. Cook for 3 minutes, then carefully remove with a slotted spoon. Serve the egg with **toast** and a little **salt** and **pepper**.

→ **FRY an egg** by cracking it into a nonstick skillet with **2 tablespoons olive oil** over medium heat. As it fries, baste the whites with the olive oil.

Make it a Meal

FRITTATA
Make a frittata by combining **eggs** with the **sautéed vegetable of your choice**, **a handful of cheese**, and **a pinch of salt** and **pepper**. Cook on the stovetop over medium heat for 5 minutes, then transfer to the oven and bake at 350°F until firm and golden brown, about 25 minutes.

TOAST
Cut a 3-inch hole in **a piece of toast**, add **an egg**, and fry in a little **olive oil** until golden.

PASTA
Toss **an egg yolk** with **freshly cooked pasta** and **a little pasta water** to create a silky sauce.

PIZZA
Crack **an egg** onto **a pizza** before baking it, for a little extra something.

Tropical Mango and Coconut Smoothie Bowl

Sweet, Cold, Refreshing

MAKES 1 SMOOTHIE BOWL

In a blender, combine **1 cup of frozen mango chunks**, **1 frozen banana**, and **½ cup of unsweetened coconut milk**. Blend until smooth, adding more milk, if needed.

Top the bowl with **unsweetened toasted coconut flakes**, **fresh diced mango**, **sliced banana**, and a sprinkling of **chia seeds**.

TIPS Skip the topping to make this a drinkable smoothie rather than a smoothie bowl by adding a little more coconut milk to loosen it up. Skip the chia seeds if they are hard to find nearby.

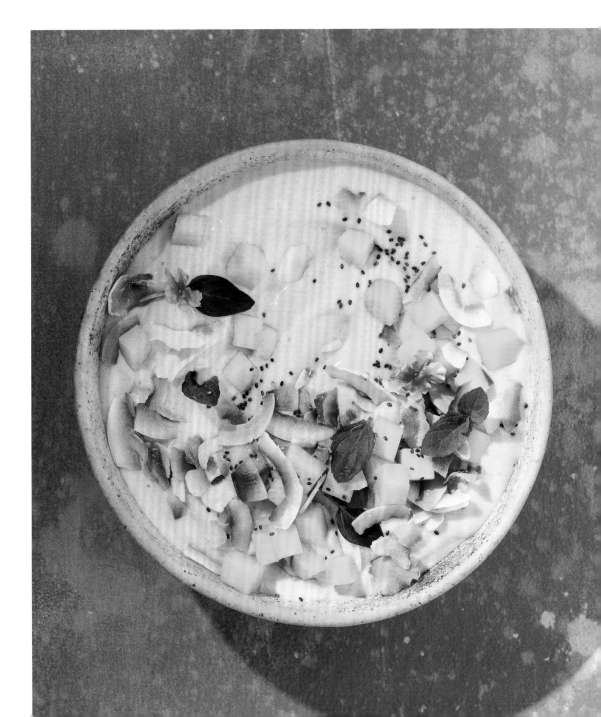

Baked Eggs in Prosciutto Cups

Savory, Creamy, Salty

MAKES 6 EGG CUPS

Preheat the oven to 350°F. Grease a 6-cup muffin pan.

Divide **4 ounces of prosciutto** among the 6 muffin cups, making sure to carefully cover all of the surfaces of the muffin cups. Sauté down **4 cups of fresh spinach** in a dry skillet over medium heat. Let the spinach cool slightly and gently squeeze out any excess liquid from the spinach, then divide among the prosciutto-lined cups. Carefully crack **6 eggs** into the 6 muffin cups. Sprinkle each with black pepper.

Bake the cups for 16 to 18 minutes, until the whites are just set and the yolk is still runny. Serve immediately.

TIP To make this recipe even easier on a busy morning, fill the muffin pan with prosciutto and spinach the night before and refrigerate. When ready to eat, crack the eggs into the muffin cups, bake, and eat.

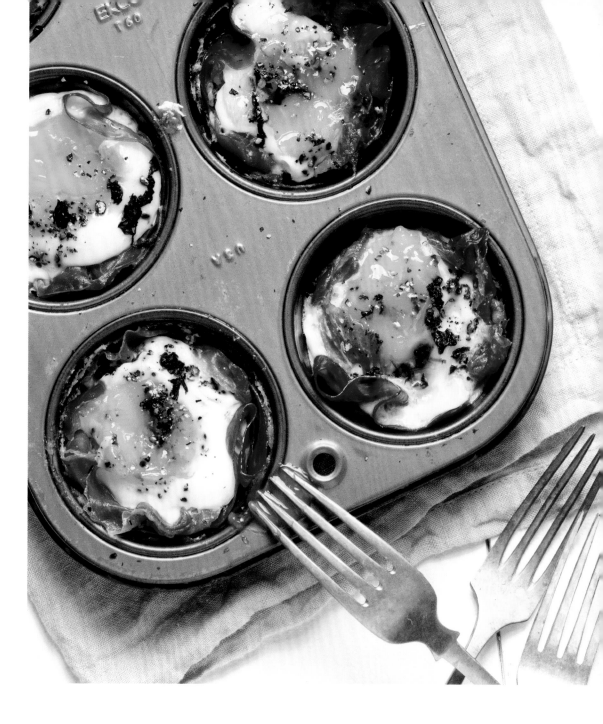

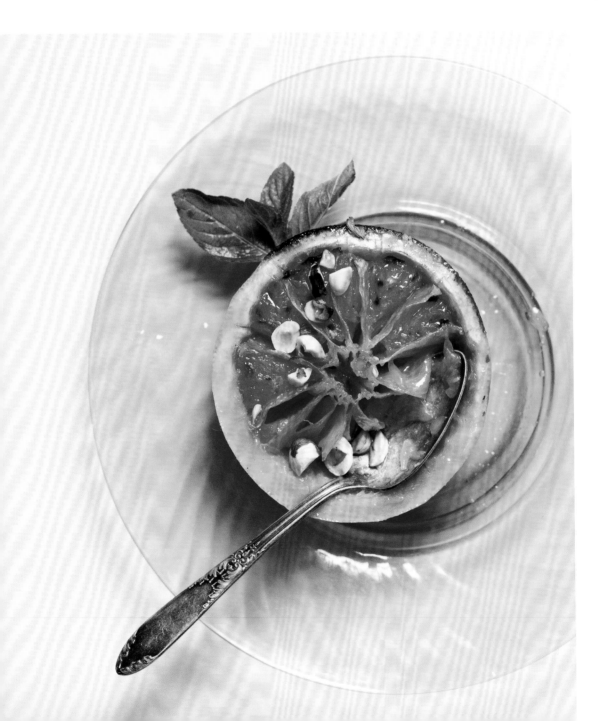

Oven-Roasted Grapefruit with Hazelnuts

Bright, Citrusy, Nutty

SHOPPING LIST
Turbinado sugar
Roasted hazelnuts
Ruby Red
grapefruits
Butter

SERVES 4

Preheat the oven to 425°F.

Cut **2 Ruby Red grapefruits** in half horizontally. Using a sharp paring knife, loosen the grapefruit segments by first carefully cutting between the fruit and the peel and then by cutting along either side of each segment. Place cut-side up in an ovenproof casserole dish. Divide **2 tablespoons of butter** into small bits and scatter among the cut sides of the grapefruit along with **2 tablespoons of turbinado sugar** or **light brown sugar**.

Roast the grapefruit for about 30 minutes, or until the edges begin to turn golden brown. Sprinkle the grapefruit with **4 tablespoons of roasted, skinned, and chopped hazelnuts** and **a pinch of flaky sea salt.** Drizzle any juices in the roasting pan over the grapefruit, then serve.

TIP Cut a thin slice from the bottom of each half of grapefruit to create a flat, stable surface before you bake them.

LONG LAZY

BRUNCHES

Homemade Ricotta with Jam on Toast

Creamy, Sweet, Crunchy

MAKES ABOUT 20 OUNCES RICOTTA,
ENOUGH FOR 8 PIECES OF TOAST

Heat **8 cups of whole milk, 1 cup of heavy cream, 6 tablespoons of lemon juice**, and **1 teaspoon salt** over medium heat in a heavy, nonreactive pot until it reaches 180°F. Stir gently to mix, then keep the mixture on the heat for 20 minutes, making sure the temperature doesn't dip below 175°F or exceed 185°F. Remove from the heat and let sit for 30 minutes.

Using a slotted spoon, scoop the ricotta out and let drain in a colander lined with paper towels or a cheesecloth until all of the excess liquid has drained away, about 10 minutes. Let the ricotta cool to room temperature before serving, or store the ricotta in an airtight container in the refrigerator for up to 1 week.

Serve with your favorite **jam**, **toast,** and **fruit** toppings, such as fresh cherries or strawberries.

TIPS Using a thermometer is the key to getting silky and smooth ricotta. For brunches, make a big batch of this ricotta the night before. Set out toppings the morning of, along with the ricotta, and let your guests mix and match to make their ricotta toast.

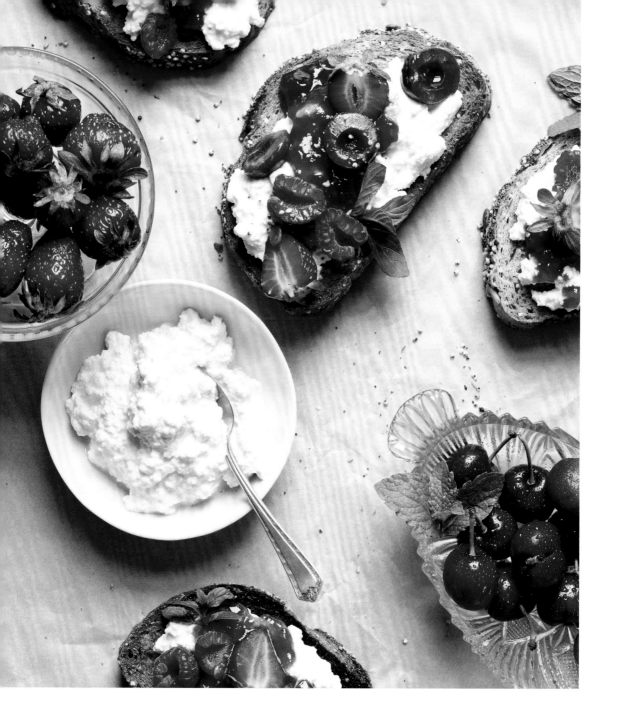

Baked Croque Madame

Nostalgic, Hearty, Decadent

SERVES 4 TO 6

Preheat the oven to 350°F. Grease a 9 by 13-inch casserole dish.

Lay **12 square pieces of thick-cut bread** (such as Texas Toast) on a sheet pan. Use a cookie cutter to cut a 2-inch circle through 6 of the pieces of bread. Toast all 12 pieces of bread in the preheated oven for 10 to 12 minutes, until the edges are golden. Set aside. Grate **3 cups of Gruyère cheese** and set aside.

To make the cheese sauce, in a saucepan, melt **4 tablespoons of butter** over medium heat, add **¼ cup flour**, and mix well. Whisk in **3 cups of whole milk** and bring to a boil. Lower the heat, add **a pinch of nutmeg, 1 teaspoon of salt**, and **a pinch of black pepper**, and cook until the mixture becomes thick. Fold in 1 cup of the grated Gruyère cheese and stir until melted.

Ladle 1 cup of the cheese sauce into the casserole dish. Divide **¼ cup Dijon mustard** and **12 pieces of thinly sliced ham** evenly over the 6 uncut pieces of bread; place the pieces in the casserole dish. Ladle in 1 cup of the cheese sauce, followed by 1 cup of the grated Gruyère cheese. Top with the remaining 6 slices of bread with the holes cut out. Drizzle the remaining cheese sauce over the top and sprinkle the remaining grated Gruyère cheese on top, avoiding the holes.

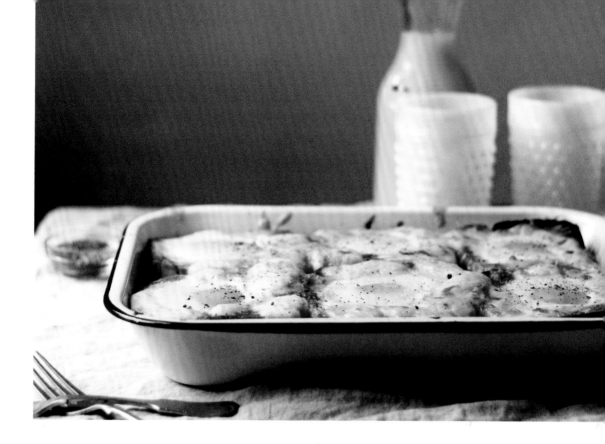

Cover with aluminum foil and bake for 20 minutes.

Remove from oven, scoop out any hole that the cheese sauce may have settled in, and carefully crack **6 eggs**, one into each hole in the bread pieces.

Return to the oven and bake uncovered for another 12 to 14 minutes, until the egg whites are just set and the edges of the bread are golden. Broil for 2 to 3 minutes to get the edges brown; let the casserole sit briefly before serving.

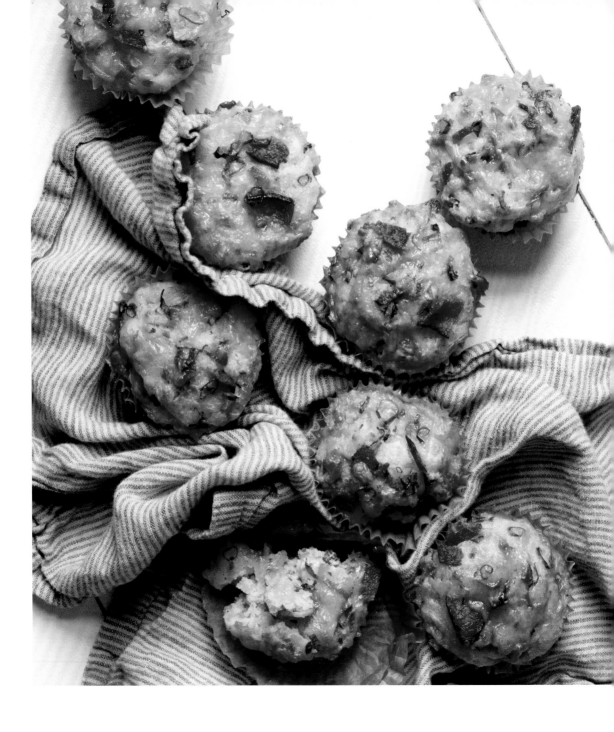

Breakfast Muffins with Bacon and Scallions

Salty, Savory, Indulgent

SHOPPING LIST

Flour
Baking powder
Baking soda
Sugar
Scallions
Egg
Cheddar cheese
Buttermilk
Bacon

MAKES ABOUT 10 MUFFINS

Preheat the oven to 425°F. Line a muffin pan with paper liners.

Dice **6 strips of bacon**; add to a large skillet over medium heat and cook until crisp, about 6 minutes. Using a slotted spoon, transfer to a paper towel–lined plate. Reserve ¼ cup of bacon fat.

In a medium bowl, whisk to combine **1½ cups of flour**, **1 teaspoon of baking powder**, **1 teaspoon of baking soda**, **2 teaspoons of sugar**, **½ teaspoon of salt**, **1½ cups of grated sharp Cheddar cheese**, **⅓ cup of thinly sliced scallions**, and the **cooked bacon**.

In a small bowl, combine **1 cup of buttermilk**, **1 egg**, and the bacon fat. Mix into the dry ingredients until just combined.

Scoop the batter into the prepared muffin pan and sprinkle the tops with **½ cup grated Cheddar cheese**.

Bake for 15 to 18 minutes, until a toothpick inserted into a muffin comes out clean and the tops are golden brown. Serve warm.

TIPS These muffins taste the best when the bacon is still warm. If you make them for a brunch, you can cook off the bacon, save in the fridge overnight, along with all of the portioned ingredients. First thing in the morning, combine the wet and dry ingredients and bake.

Fruit Salad with Limoncello and Whipped Mascarpone Cheese

Sweet, Fresh, Creamy

SERVES 6 TO 8

In a small bowl, beat together **1 cup of heavy cream** and **¼ cup of honey** until just barely stiff peaks form. Fold in **8 ounces of mascarpone cheese**. Refrigerate.

In a large bowl, combine **1 pint of hulled sliced strawberries**, **1 pint of blueberries, 1 pint of blackberries, 1 pint of raspberries**, **2 peeled and sliced kiwis, 2 peeled and sectioned oranges**, and **¼ cup limoncello**. Mix well and let sit for 5 minutes. Fold in **2 sliced bananas** and serve immediately alongside the whipped mascarpone cheese.

TIPS Use any combination of your favorite fruits. The limoncello adds a sweet flavor to the fruit salad but feel free to swap it with ¼ cup fresh orange juice.

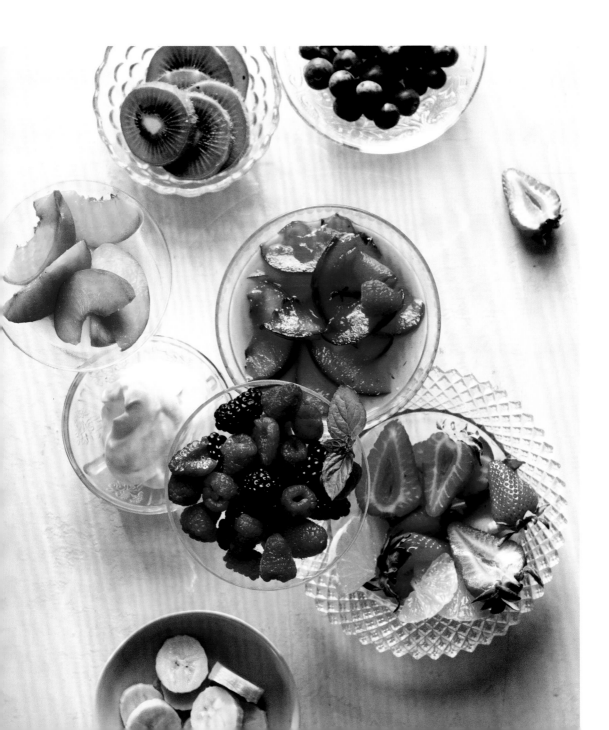

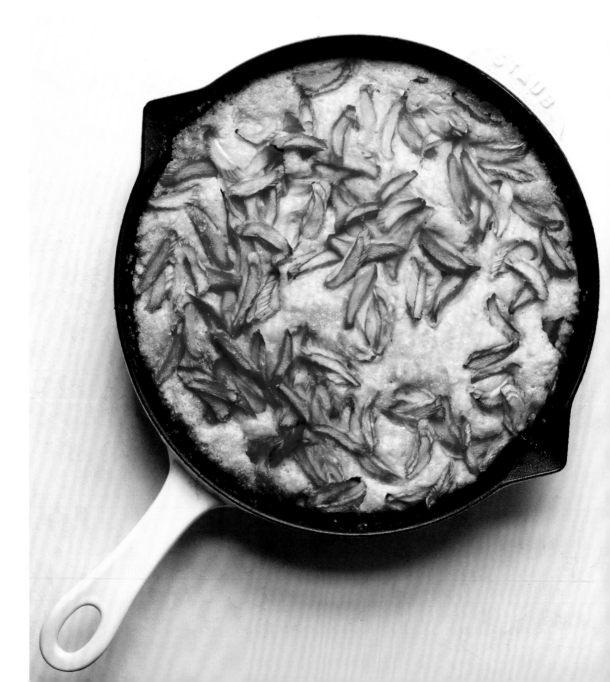

Oven-Baked Pancake with Lemon and Rhubarb

Bright, Sweet, Warm

SERVES 4 TO 6

SHOPPING LIST
Flour
Sugar
Turbinado sugar
Baking powder
Vanilla extract
Maple syrup
Lemon
Rhubarb
Eggs
Butter
Sour cream

Preheat the oven to 350°F with a 10-inch cast-iron skillet in the oven.

In a medium bowl, whisk together **1½ cups of flour**, **⅓ cup of sugar**, **2 teaspoons of baking powder**, and **¾ teaspoon of salt**.

In a small bowl, whisk together **1¼ cups of sour cream**, **2 eggs**, **1 egg yolk**, **finely grated zest of 1 lemon**, **3 tablespoons of melted butter**, and **1 teaspoon vanilla extract**.

Whisk the wet ingredients into the dry ingredients until just barely combined.

Carefully remove the skillet from the oven, add **1 tablespoon of butter**, and swirl the pan to cover the bottom with the butter. Pour the batter into the pan, then top with **1 cup of thinly sliced rhubarb** in an even layer. Sprinkle with **1 tablespoon of turbinado sugar** or **light brown sugar** and bake for 30 to 35 minutes, until golden brown. Serve slices with **a drizzle of maple syrup**.

TIPS Make sure to thinly slice the rhubarb so it cooks through. The recipe is not very sweet, so it should be served with maple syrup. If you want to skip the maple syrup, increase the sugar in the recipe to ½ or ⅔ cup.

Maitake Mushroom Frittata with Crunchy Micro Greens

Satisfying, Umami, Textured

SERVES 4

Preheat the oven to 375°F.

In a large well-seasoned or enameled cast-iron pan, warm **1 tablespoon of olive oil** over medium heat, then add **1 thinly sliced leek**. Sauté until soft, 4 to 6 minutes. Add **8 ounces of chopped maitake mushrooms**, **2 teaspoons of chopped fresh thyme**, **a pinch of salt**, and **a pinch of black pepper**. Sauté over medium heat for 5 to 7 minutes, until the mushrooms are soft.

In a bowl, beat together **8 eggs**, **½ cup milk**, **a pinch of salt**, and **a pinch of black pepper**. Fold in **1 cup of grated fontina cheese**.

Pour the egg mixture over the mushrooms and stir to combine. Cook over medium-low heat for about 5 minutes, until the edges just begin to set. Transfer to the oven and bake for 20 to 25 minutes, until golden brown. Serve the frittata immediately topped with **a handful of micro greens**.

TIPS Replace the maitake mushrooms with the more readily available shiitake or cremini mushrooms. If you can't find micro greens, arugula, or even sprouts, work in their place.

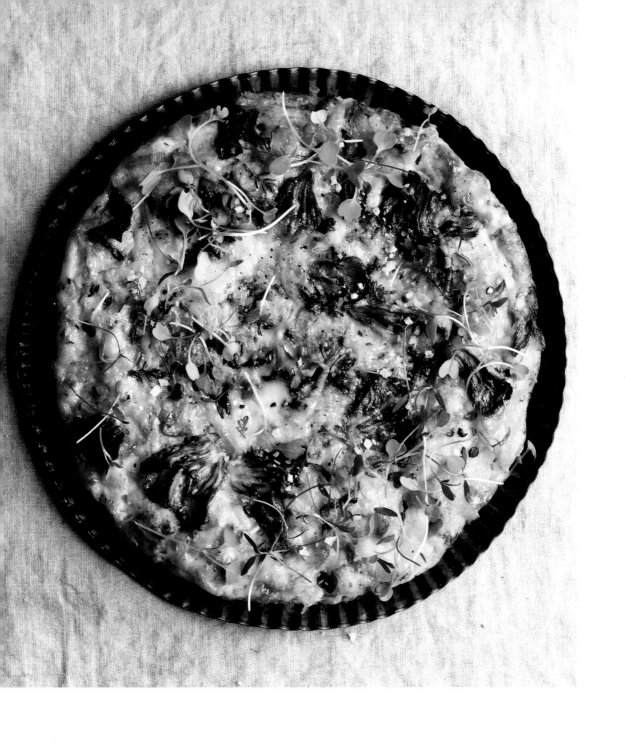

Overnight Brioche French Toast with Caramelized Bananas

Comforting, Sweet, Tropical

MAKES ABOUT 6 SERVINGS

In a large bowl, whisk together **6 eggs**. Add **2 ½ cups of half-and-half**, **2 tablespoons of brown sugar**, **1 tablespoon of rum**, **1 teaspoon of ground cinnamon**, **½ teaspoon of ground cloves**, and **a pinch of salt**.

Layer **1 (1-pound) loaf of sliced brioche**, overlapping slightly, in a greased 9 by 13-inch baking dish. Pour the egg mixture over the brioche, cover with plastic wrap, and refrigerate overnight.

Preheat the oven to 350°F.

Remove the plastic wrap, cover the baking dish with aluminum foil, and bake for 40 minutes. Remove the foil and bake for another 20 minutes, or until the edges of the brioche are golden brown. Let cool slightly.

Meanwhile, melt **4 tablespoons butter** over medium heat in a skillet. Add **¼ cup firmly packed brown sugar** and whisk until the sugar is incorporated. Add **2 sliced bananas**, **2 tablespoons of rum**, and **a pinch of salt**. Cook for 2 to 3 minutes, until the liquid is syrupy and the bananas are caramelized. Serve the French toast with a spoonful of the caramelized bananas and **maple syrup**.

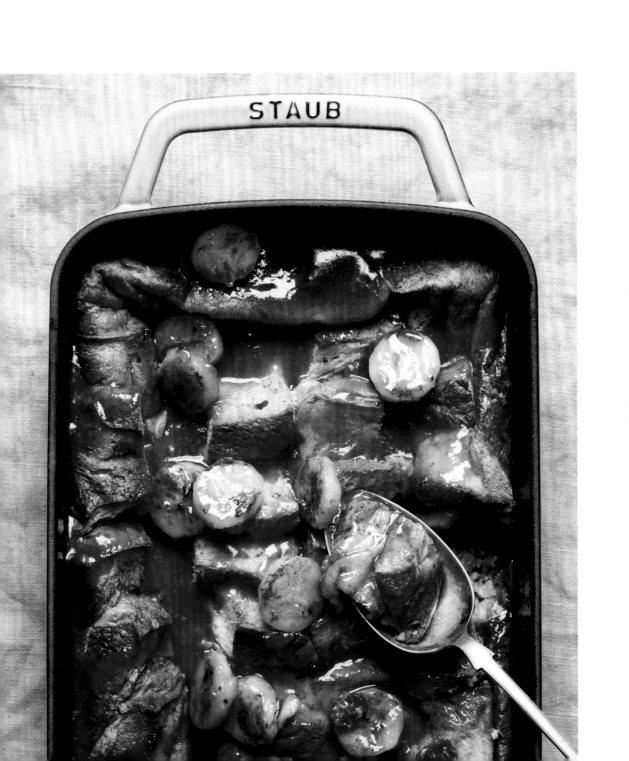

Smoked Trout Hash

Savory, Crispy, Healthy

SERVES 4 TO 6

Preheat the oven to 350°F.

Put **1 pound of fingerling potatoes** in a pot and cover with water. Bring to a boil and cook until the potatoes are fork tender, about 20 minutes. Carefully remove the potatoes. Add **8 ounces of asparagus spears cut into 2-inch pieces** to the boiling water and blanch for 3 to 5 minutes, until the asparagus is bright green and fork tender. Drain the asparagus and plunge into an ice bath to stop cooking.

Pulse a few slices of rye bread in your food processor or blender. Warm **2 tablespoons of olive oil** in a large skillet over medium-low heat. Add **½ cup fresh rye bread crumbs** and sauté until the crumbs are golden brown and crispy, about 3 minutes. Remove and set aside.

Warm **2 tablespoons of olive oil** in the same large skillet over medium-high heat. Add **12 ounces of roughly chopped trumpet mushrooms** and sauté until soft, 6 to 8 minutes. Remove from the pan with a slotted spoon and set aside.

In the same skillet, adding more olive oil if needed, sauté **1 thinly sliced onion** and **1 large peeled and thinly sliced carrot** until fork tender, 4 to 6 minutes. Add the blanched asparagus and cook

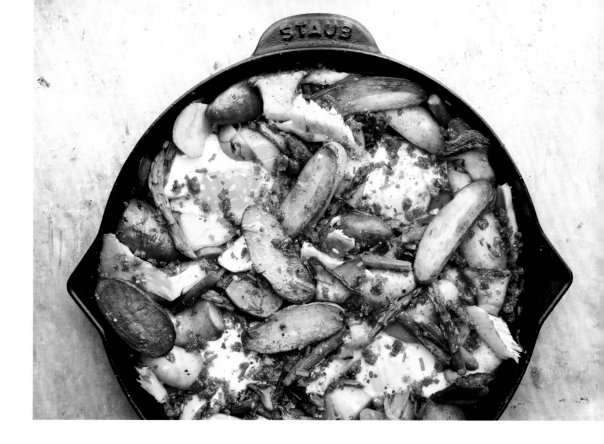

for another 3 minutes. Add the cooked potatoes, followed by the cooked mushrooms. Break **8 ounces of smoked trout** into small pieces and stir in. Make 5 indentations in the mixture for **5 eggs**. Crack 1 egg into each indentation. Top with the bread crumbs. Bake for 12 minutes, or until desired doneness.

Sprinkle with a couple of tablespoons of **chopped fresh herbs** (any kind that you like and have on hand) and serve immediately.

TIPS If you can't find smoked trout, smoked salmon works in its place. Trumpet mushrooms are meaty and delicious, but if they are hard to find, you can replace them with more readily available mushrooms like button or cremini. Use store-bought dried bread crumbs if you don't have rye bread.

THE FRUITS

AND

VEGGIES

Citrus Salad with Avocado, Roasted Pistachios, and Mint

Simple, Savory, Fresh

SERVES ABOUT 4

Carefully peel and thinly slice **4 Cara Cara oranges** and **1 Ruby Red grapefruit** and place them on a plate. Top with **1 thinly sliced avocado, a sprinkle of flaky sea salt**, and **a drizzle of olive oil**. Top with **¼ cup chopped roasted pistachios** and **a handful of fresh mint leaves** and serve.

TIPS If you can't find Cara Cara oranges, use blood oranges or regular navel oranges. If you can't find Ruby Red grapefruit, use pink or regular grapefruit.

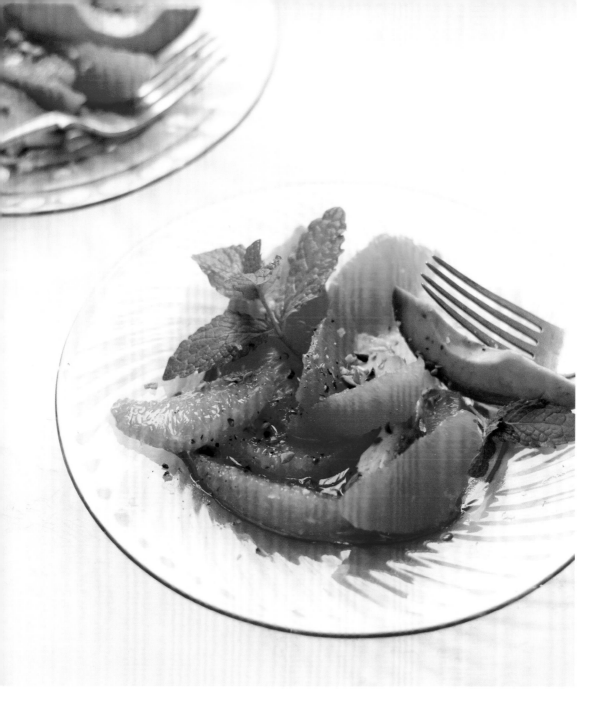

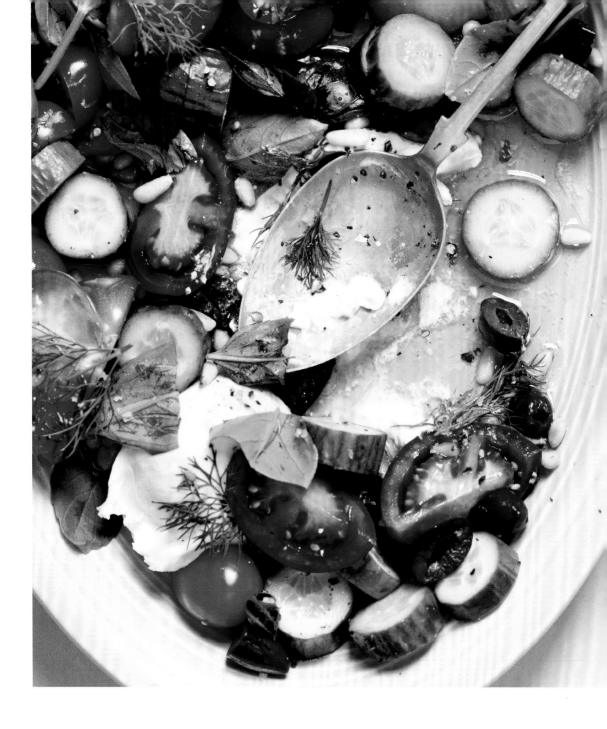

Cucumber Salad with Heirloom Tomatoes, Black Olives, and Burrata

Fresh, Simple, Vibrant

SHOPPING LIST

Pine nuts

Olive oil

Pitted black olives

Lemon

Cucumbers

Heirloom tomatoes

Fresh soft herbs

Burrata

SERVES ABOUT 4

In a large bowl, combine **2 sliced small cucumbers, 2 diced heirloom tomatoes**, and **½ cup of pitted and crushed black olives**. Tear **8 ounces of Burrata** over the cucumber mixture and top with a **large handful of coarsely chopped fresh soft herbs** like basil, mint, dill, or cilantro and **½ cup of toasted pine nuts** (see page 139 for toasting instructions). Drizzle with the **juice and finely grated zest of 1 lemon** and **¼ cup of olive oil**. Sprinkle on **a pinch of flaky sea salt** and **a pinch of black pepper**. Serve immediately.

TIPS Fresh herbs and in-season heirloom tomatoes make this simple dish spectacular. Make sure to seek them out. Consider serving this salad with some fresh bread for mopping up all the yummy flavors.

Green Apple, Radicchio, Hazelnut, and Goat Cheese Salad

Crunchy, Bitter, Fresh

SERVES ABOUT 4

To make the dressing, whisk together **1 small minced shallot,
¼ cup of red wine vinegar**, **2 teaspoons of maple syrup,
2 teaspoons of Dijon mustard**, **a pinch of salt**, and **a pinch of
black pepper**. Pour in **½ cup of unrefined walnut oil**, whisking
to create an emulsion.

Tear **1 head of radicchio** into bite-size pieces and combine with
2 cored and thinly sliced apples; **¼ cup of roasted, skinned, and
chopped hazelnuts**; and **2 ounces of crumbled soft goat cheese**
in a large bowl. Drizzle half of the dressing over the salad. Toss
well and taste for **salt** and **pepper**. Add more dressing as needed.
Serve immediately.

TIPS Unrefined walnut oil can be found at most grocery stores. If you can't
find it, replace with olive oil. Radicchio is a bitter green with a distinctive
taste, but you can use romaine or Little Gem lettuce in its place. Store any
unused dressing for up to a week in an airtight container in the fridge.

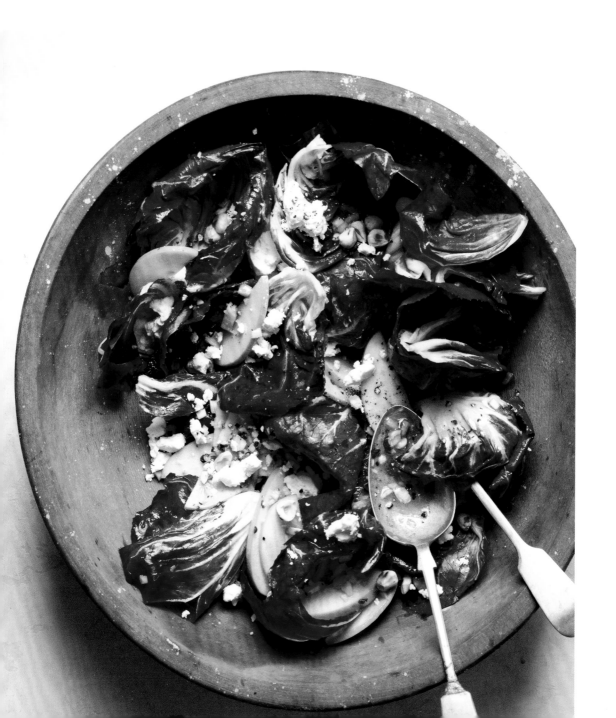

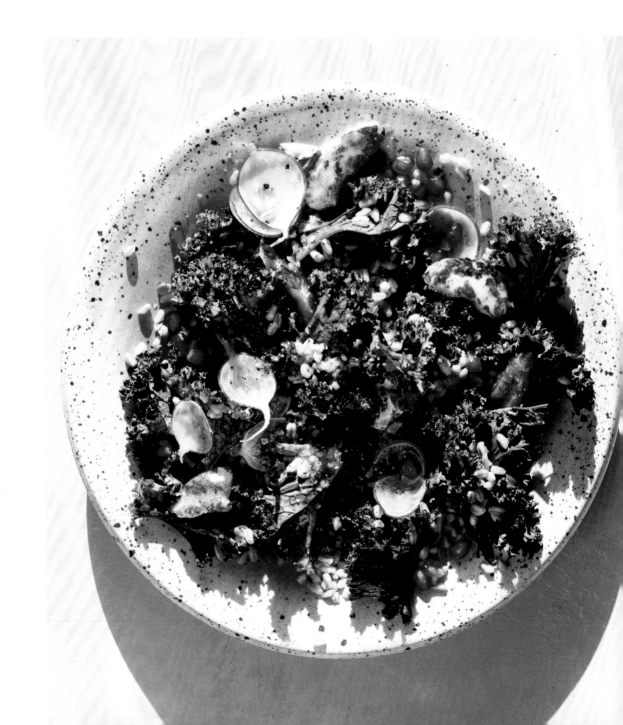

Kale, Farro, and Halloumi Salad with Tahini Vinaigrette

Salty, Bright, Chewy

SERVES 4

To make the vinaigrette, whisk together **¼ cup of fresh lemon juice**, **1 teaspoon of honey**, **1 tablespoon of tahini**, **¼ cup of olive oil**, **a pinch of salt**, and **a pinch of black pepper**. Set aside.

Add **1 cup of farro** to a pot of salted boiling water and cook until al dente, 15 to 20 minutes. Drain and let cool.

In a nonstick pan, warm **2 tablespoons of neutral oil** over medium heat. Add **8 ounces sliced halloumi** and sear for about 2 minutes, flipping halfway through.

Remove the ribs and thinly slice **2 bunches of kale**. In a large bowl, toss the kale with a drizzle of the vinaigrette. Add the farro, sliced halloumi, **1 cup of sliced radishes**, and **¼ cup of pomegranate seeds**. Add more dressing if needed and taste for **salt** and **pepper**. Serve immediately.

TIPS Halloumi is a salty, chewy cheese. If you can't find it, use feta cheese instead, but don't warm it in a skillet. Don't add too much salt to the dressing and instead wait until the salad is put together with the halloumi before adding more salt. Kale can be tough and fibrous but slicing it really thin tenderizes it.

Kohlrabi Caesar Salad

Briny, Tangy, Crunchy

SERVES ABOUT 4

To make the dressing, sprinkle **a pinch of salt** over **2 minced cloves of garlic** on a cutting board. Using the back of a knife, mash the garlic until smooth. In a small bowl, whisk together the garlic paste, **1 teaspoon of anchovy paste**, **the finely grated zest and juice of 1 lemon**, **1 teaspoon of Dijon mustard**, **1 teaspoon of Worcestershire sauce**, **1 cup of mayonnaise**, and **½ cup of freshly grated Parmesan cheese**. Taste for **salt** and **pepper**.

In a small skillet, warm **¼ cup olive oil** over medium heat. Tear **4 slices of country bread** into bite-size pieces, add to the skillet, and cook until golden brown, 3 to 5 minutes. Sprinkle with **salt** and set aside on a paper towel–lined plate.

In a large bowl, toss together **1 pound of thinly sliced kohlrabi**, **1 coarsely chopped head of romaine**, the toasted bread, and a drizzle of the salad dressing. Taste for **salt and pepper**. Serve the salad topped with more **grated Parmesan cheese** and a couple of tablespoons of **coarsely chopped fresh herbs** like chives or basil. Refrigerate any unused dressing in an airtight container.

TIPS If you can't find kohlrabi, you can use other vegetables like cabbage or even radish. Country bread is another term used for breads like baguettes and ciabatta that have a crispy crust and a clean simple flavor.

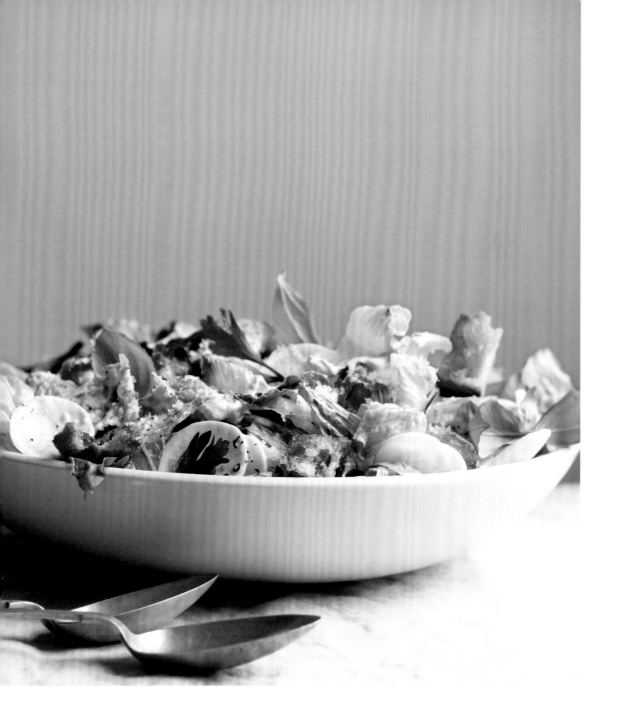

SHOPPING LIST
Olive oil
Capers
Garlic
Lemon
Artichokes
Fresh mint
White wine

Pan-Roasted Artichokes with Mint and Capers

Fresh, Savory, Light

SERVES 4 TO 6

Fill a large bowl with cold water and add a **couple of lemon slices**. Prepare an ice bath.

Cut **4 trimmed artichokes** into halves and scrape out and discard the hairy chokes. Put the artichokes in the lemon water as you work. Drain the artichokes and pat dry.

In a large skillet, warm **2 tablespoons of olive oil** over medium-high heat. Place the artichokes cut-side down in the pan and lower the heat to medium-low. Scatter **2 cloves of thinly sliced garlic** over the artichoke halves, add **a pinch of salt**, and cook, without stirring, just until the garlic is golden, about 3 minutes.

Add **1½ cups of dry white wine**; cover the pan, lower the heat, and simmer, without stirring, until the artichoke stems are very tender, 10 to 15 minutes.

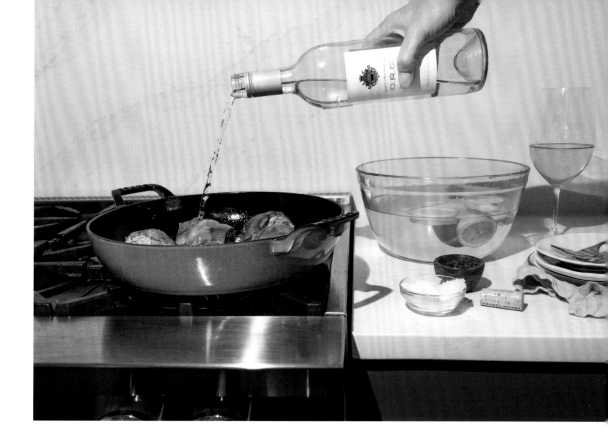

Remove the lid, add **1 tablespoon of capers**, and cook, uncovered, until the wine has almost evaporated, the artichokes are soft, and the cut side is golden brown, about 3 minutes.

Serve the artichokes warm or room temperature, drizzled with pan juices, **chopped fresh mint**, and **a large pinch of flaky sea salt**.

SHOPPING LIST

Coconut oil

Sriracha

Lime

Sweet potatoes

Cilantro

Roasted Sweet Potatoes with Sriracha and Lime

Spicy, Bright, Fresh

SERVES 4 TO 6

Preheat the oven to 425°F.

Finely grate the zest of and juice **1 lime**. In a large bowl, whisk together **¼ cup of melted coconut oil**, the lime juice (save the zest for garnish), **2 teaspoons of salt**, and **2 teaspoons of Sriracha**.

Cut **1½ pounds unpeeled sweet potatoes** into 1-inch chunks and toss in the mixture. Roast in a single layer on two sheet pans, for 35 to 45 minutes until fork tender, tossing occasionally and switching the pans halfway through.

Transfer to a serving platter. Top with the lime zest and **a handful of coarsely chopped fresh cilantro leaves**. Serve immediately.

TIPS Exact roasting time for the sweet potatoes will vary depending on their thickness. If Sriracha doesn't seem hot enough, add more at the end. But, be warned: the Sriracha heat builds over time after each bite of sweet potato.

Zucchini Salad with Meyer Lemon Vinaigrette, Pine Nuts, and Fresh Herbs

Fresh, Crunchy, Bright

SHOPPING LIST

Pine nuts
Olive oil
Dijon mustard
Meyer lemon
Shallot
Zucchinis
Fresh soft herbs
Parmesan cheese

SERVES ABOUT 4

In a small bowl, whisk together **¼ cup of Meyer lemon juice**, **¼ cup of olive oil**, **1 minced shallot**, **1 teaspoon of Dijon mustard**, **a big pinch of salt**, and **a pinch of black pepper**.

Place **3 thinly sliced zucchinis** in a big bowl, followed by **¼ cup of toasted pine nuts** (see page 139 for toasting instructions), **a handful of chopped soft herbs such as basil or chives**, and a **sprinkle of freshly grated Parmesan cheese**. Add a drizzle of the dressing and toss well. Taste for **salt** and **pepper** and serve.

TIP Meyer lemon juice adds a floral element to the dressing. If you can't easily find Meyer lemons, use regular lemons.

SHOPPING LIST
Olive oil
Green beans
Corn
Cherry tomatoes
Red onion
Jalapeño
Limes
Fresh basil

Tomato, Green Bean, and Corn Salad

Fresh, Bright, Summery

SERVES 4 TO 6

Bring a large pot of salted water to a boil. Prepare an ice bath. Add **8 ounces of trimmed and halved green beans** and blanch for 5 to 7 minutes, until the beans are crunchy and bright green. Plunge into an ice bath to stop the cooking.

In a large bowl, combine the kernels stripped from **2 ears of fresh corn; 1 pint of cherry tomatoes, halved; ½ minced red onion; 1 minced jalapeño with the seeds removed**; and the blanched green beans. Give it a big stir, then top with the **juice of 2 limes, ¼ cup of olive oil**, a handful of coarsely chopped fresh basil, **a large pinch of flaky salt**, and **a pinch of black pepper**. Toss well, taste for salt, then serve.

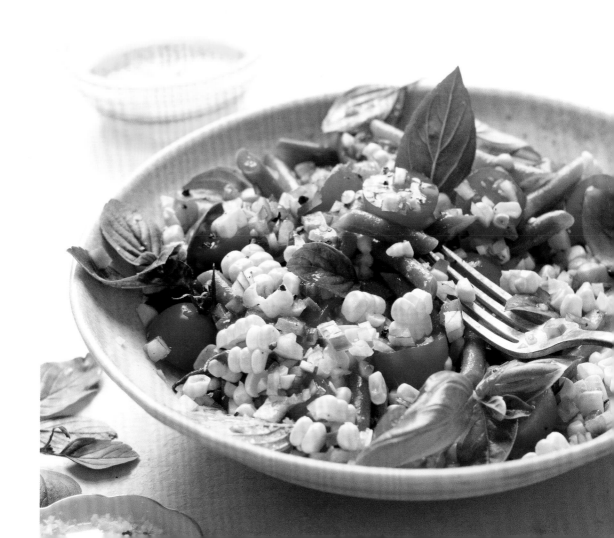

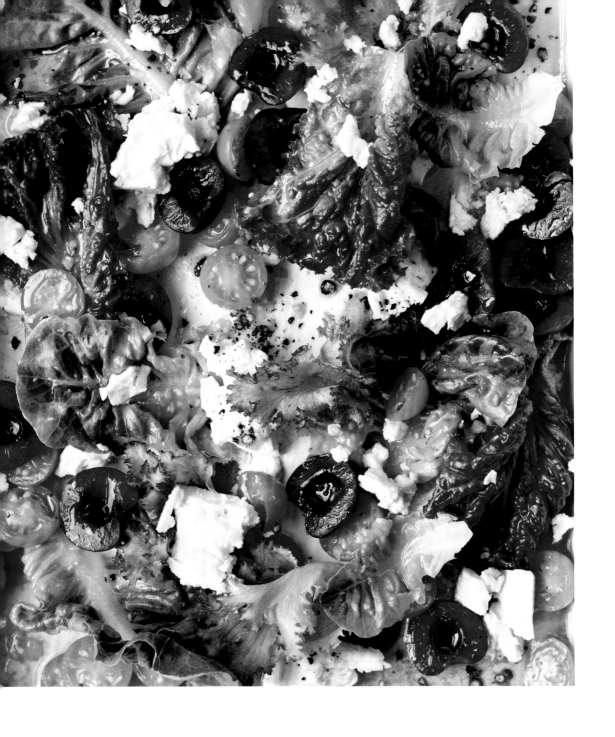

Sungold Tomato and Cherry Salad with Baked Feta and Little Gem Lettuce

Savory, Fresh, Crunchy

SERVES 4

Preheat the oven to 400°F.

Place **1 (8-ounce) block of feta** in a small ovenproof dish. Drizzle with **¼ cup of olive oil**. Roast the feta for 8 minutes, or until soft. Carefully drizzle with **1 tablespoon of honey** and continue baking for 1 minute more, or until the top of the feta is light golden brown.

In a large bowl, combine **1 pint of Sungold tomatoes** and **1 cup of pitted and halved cherries**. Tear and add **2 heads of Little Gem lettuce**.

Carefully drain the oil from the feta. Mix with **¼ cup of red wine vinegar** and drizzle over the salad. Serve the salad topped with chunks of the warm feta. Taste for **salt** and **pepper** and serve immediately.

TIPS If you can't find Sungold tomatoes, any sweet cherry tomato works in its place. Romaine lettuce can replace the Little Gems.

SHOPPING LIST

Olive oil

Honey

Red wine vinegar

Sungold tomatoes

Cherries

Little Gem lettuce

Feta cheese

SHOPPING LIST
Chili powder
Cantaloupe
Honeydew melon
Lime
Fresh mint

Melon Salad with Chili Powder, Mint, Lime, and Flaky Sea Salt

Light, Refreshing, Spicy

SERVES ABOUT 4

Peel, seed, and slice **½ cantaloupe** and **½ honeydew melon**. Arrange on a plate and top with the **zest of 1 lime**, **a handful of chopped fresh mint**, **a pinch of chili powder**, and **a sprinkle of flaky sea salt**. Serve immediately.

TIP Feel free to use all cantaloupe or honeydew melon instead of half and half.

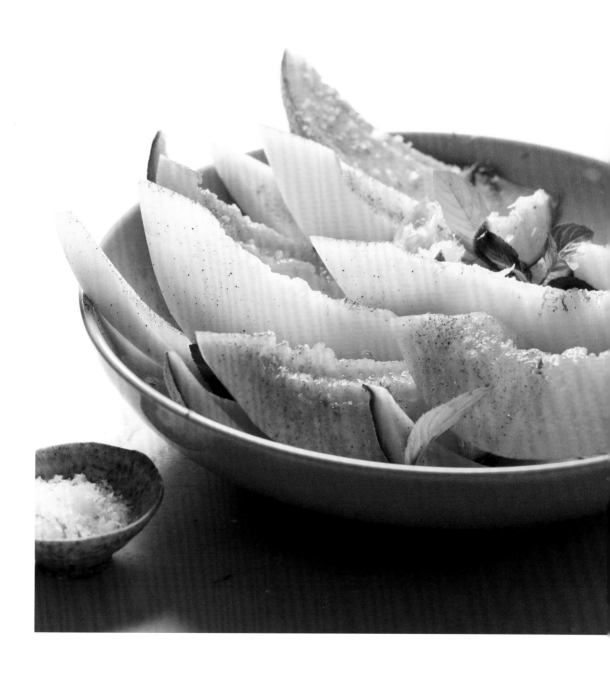

LIGHT

BITES

Salmon and Avocado Nori Wraps

Umami, Hearty, Healthy

MAKES 4 WRAPS

Preheat the oven to 450°F.

Place **2 (4-ounce) fillets of salmon** skin-side down on a sheet pan lined with parchment paper. Sprinkle with **salt** and **black pepper** and drizzle with **toasted sesame oil**. Roast for about 10 minutes or until the tip of a paring knife can be inserted without any resistance. Let rest until cool to touch. Using a fork, flake the salmon so it separates from the skin.

Finely mince **1 tablespoon of chopped pickled ginger**. Stir into **¼ cup of mayonnaise**.

Assemble the wraps by placing **4 sheets of nori** on a flat surface. Spread each sheet with the pickled ginger mayonnaise and top with the salmon, **½ thinly sliced cucumber**, **1 sliced avocado**, and **a handful of coarsely chopped fresh mint** or **cilantro leaves**. Carefully wrap the nori around the filling and serve immediately.

TIPS Consider adding brown rice to make this a more filling meal. The mayonnaise can cause the nori to get soggy if not eaten immediately. If you are taking this meal to work as lunch, make it into a bowl by topping the salmon, cucumber, avocado, and herbs with a dollop of the mayonnaise and some crushed nori. If you can't find nori at your market, either skip it or replace it with your favorite wrap.

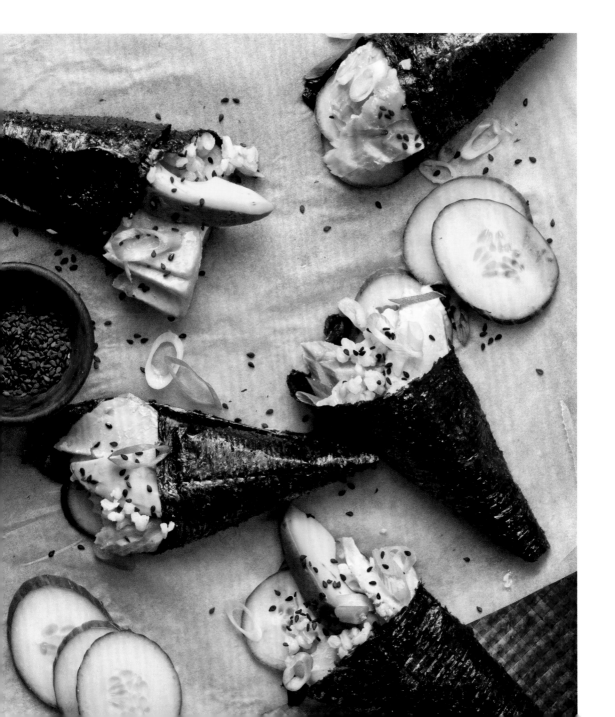

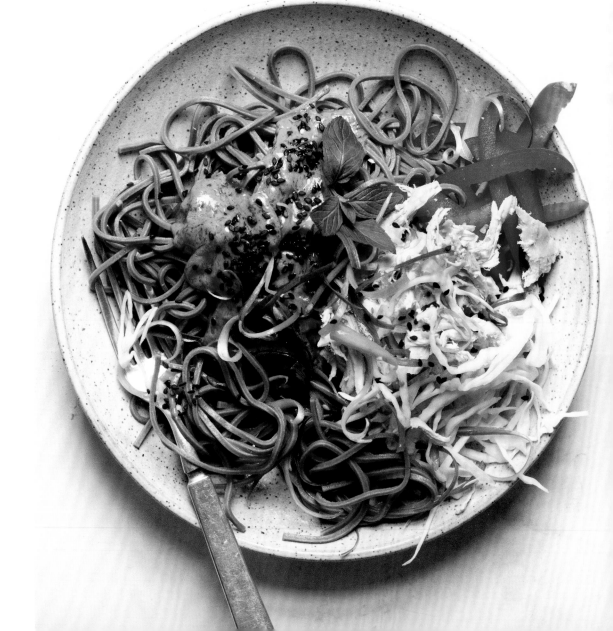

Peanut Soba with Chicken and Mint

Hearty, Creamy, Crunchy

SHOPPING LIST

Soba noodles

Neutral oil

Toasted sesame oil

Honey

Smooth peanut butter

Soy sauce

Gochujang (optional)

Garlic

Ginger

Lime

Crunchy vegetables

Fresh mint

Cooked chicken

SERVES ABOUT 4

To make the peanut sauce, warm **2 tablespoons of neutral oil** in a skillet over medium-low heat. Add **2 minced cloves of garlic** and **1 tablespoon of minced ginger** and sauté for about 30 seconds until garlic is barely golden brown. Add **½ cup of smooth peanut butter**, **¾ cup of water**, **¼ cup of soy sauce**, **¼ cup of fresh lime juice**, **1 tablespoon of honey**, **2 tablespoons of toasted sesame oil**, and **2 teaspoons gochujang** (or **more**, if you want more heat) (optional). Bring to a boil, then lower the heat to low and continue cooking and stirring until the peanut sauce is smooth and thick, 2 to 4 minutes. (Peanut sauce will look broken at the beginning but keep whisking and it will come together.) Set aside.

Cook an **8-ounce package of soba noodles** according to the package instructions. Drain and carefully rinse with cold water.

CONTINUED

Peanut Soba with Chicken and Mint

CONTINUED

Assemble the bowl by tossing the soba noodles with a couple of large spoonfuls of the peanut sauce. Fold in **1 cup of shredded cooked chicken** and **1 cup of sliced crunchy vegetables**, such as cabbage, radish, or bell pepper. Top with **½ cup of coarsely chopped fresh mint**. Serve at room temperature.

TIPS If soba noodles get sticky after being cooked, simply rinse with cool water. Feel free to use any type of crunchy vegetable you have available. Cover and store any extra peanut sauce in the fridge for up to a week. This sauce is delicious but can break if you don't whisk it together really well. If you have a blender, the sauce is less likely to break if you blend it for about 30 seconds until creamy, after cooking.

Riffs on a Grain Bowl

So many grains, so many ways.

1	2	3	4
Start with Cooked Grains	**Then Add Cooked Protein**	**Top with Vegetables**	**Sprinkle on Flavor Gold**
↓	↓	↓	↓
Quinoa	Grilled Chicken	Broccoli	Caramelized Onions (PAGE 227)
Rice	Steak	Sautéed Mushrooms	Tomato Vinaigrette (PAGE 227)
Wild Rice	Tofu	Roasted Sweet Potato	Tahini Vinaigrette (SEE PAGE 55)
Cauliflower Rice	Salmon	Chopped Romaine	Caesar Dressing (SEE PAGE 56)

Tofu Banh Mi Sandwiches

Filling, Herbaceous, Crunchy

MAKES 4 SANDWICHES

Slice **14 ounces of extra-firm tofu** into ½-inch-thick slices. Lay the tofu on a paper towel–lined sheet pan (or any flat surface) and cover with paper towels. Place another sheet pan on top and let the tofu sit for about an hour, allowing some of the liquid to drain off.

Combine **1 cup of julienned carrot, 1 cup of julienned cucumber**, and **1 sliced jalapeño (optional)** in a heatproof bowl or jar.

Bring **¾ cup of rice vinegar, 1 teaspoon of salt, 1 teaspoon of sugar**, and **¾ cup of water** to a boil. Reduce the heat and stir until the sugar and salt dissolve. Pour the vinegar mixture over the vegetables. Let come to room temperature and refrigerate for at least an hour, up to 1 week.

Make the tofu marinade by combining **2 minced cloves of garlic, 1 tablespoon of grated ginger, the finely grated zest and juice of 1 lime, 2 tablespoons of fish sauce**, and **¼ cup neutral oil**. Place the tofu in a shallow dish, pour the marinade over the tofu, and allow to marinate for at least an hour, or up to overnight.

Warm **2 tablespoons of neutral oil** in a large nonstick skillet over medium heat. Add the tofu and fry for about 4 minutes until golden brown, flipping halfway through.

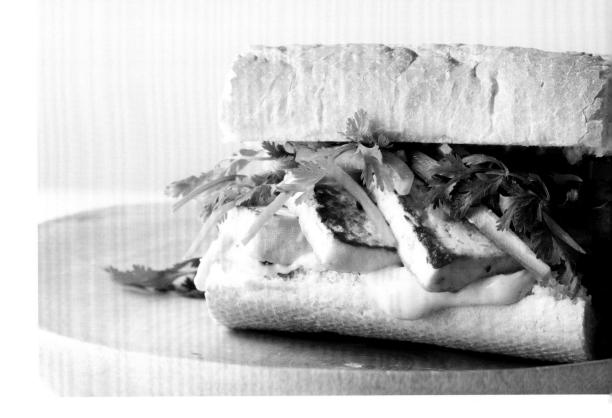

To assemble the sandwiches, spread **½ cup of mayonnaise** on both sides of **1 baguette** cut into four 4-inch pieces. Drizzle with **Sriracha** to taste. Divide the tofu among the four sandwiches, followed by a handful of the pickled vegetables and a handful of **coarsely chopped fresh cilantro or mint**. Serve the banh mi with **more fish sauce** and **Sriracha to taste**.

TIPS The pickled vegetables can be made up to a week before, saving assembly time. This recipe seems like a lot of work but much can be done in stages, and the flavor is worth it.

Rice Salad with Chickpeas, Preserved Lemon, and Almonds

Bright, Savory, Filling

SERVES 6

Cook **1 cup of wild rice** and **1 cup of jasmine rice** seperately according to their package instructions. When the rice is cooked, fluff with a fork, then spread out on a sheet pan in an even layer, and allow to cool.

Put **1 cup of whole almonds** in a small skillet. Add **2 tablespoons of olive oil** and **a pinch of salt** and sauté over low heat until fragrant, 3 to 5 minutes; be careful not to burn the almonds. Set aside on a paper towel–lined plate.

Transfer the rice to a large bowl. Drain and fold in **1 (15-ounce) can of chickpeas**, **¼ cup of chopped preserved lemon** (page 223), **2 cups of coarsely chopped soft herbs**, such as basil or parsley, **1 cup of arugula**, **1 cup of caramelized onions** (page 227), and the toasted almonds.

In a small bowl, combine **¼ cup of fresh lemon juice** and **½ cup olive oil**. Drizzle over the salad and taste for **salt** and **black pepper**.

TIP If you don't have preserved lemon, use the zest of 1 lemon.

Knife and Fork Niçoise Toast

Crunchy, Umami, Hearty

SERVES 4

Bring **1 cup of apple cider vinegar**, **1 cup of water**, **1 tablespoon of sugar**, and **1 tablespoon of salt** to a boil. Pour over **2 cups of cut green beans** (2-inch pieces) and allow the green beans to become quickly pickled by sitting at room temperature for about 1 hour.

In that same pot, cover **8 ounces of fingerling potatoes** with water and bring to a boil. Prepare an ice bath. When the water begins to boil, carefully add **2 whole eggs**. Cook the eggs alongside the potatoes for 8 minutes, then remove the eggs and plunge into an ice bath and peel and halve when cool to the touch. Continue cooking the potatoes for 7 to 9 minutes, until fork tender. Drain and let cool.

Warm **2 tablespoons of olive oil** in a large skillet over medium heat. Add **4 thick-cut slices of bread**, working in batches if needed, and fry the bread until warm and golden brown, flipping halfway through, 2 to 4 minutes. Spread **4 tablespoons of mayonnaise** over the 4 slices of bread. Divide among the bread slices **1 (5-ounce) can of drained water-packed tuna**. Carefully slice the potatoes and place on the bread slices. Top each toast with a one-quarter portion of **1 cup halved cherry tomatoes**, the pickled green beans, ¼ **cup of capers**, and **lots of herbs**. Serve with a halved egg.

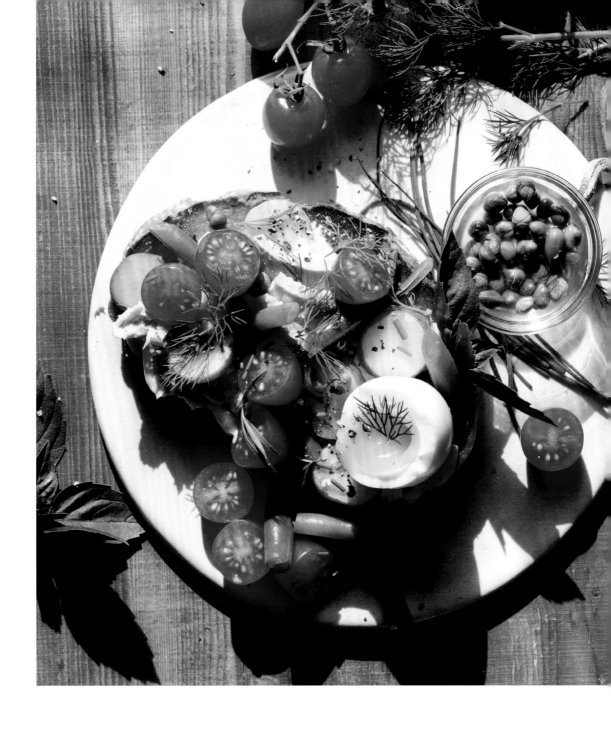

Tarragon Chicken Salad with Crème Fraîche

Filling, Salty, Satisfying

MAKES ABOUT 4 SERVINGS

Combine ½ **diced red onion** and **2 tablespoons of red wine vinegar** in a small bowl. Let sit for about 5 minutes, until the red onion is pickled. Combine the red onion and vinegar with **diced chicken from 1 whole rotisserie chicken**, **½ diced cucumber**, and **½ bulb thinly sliced fennel** in a large bowl and toss well. Add **3 tablespoons of chopped fresh tarragon**. Season with **salt** and **pepper** and set aside.

Warm ¼ **cup of olive oil** in a large skillet over medium heat. Add **1 cup fresh rye bread crumbs** (see page 44) and toast for about 3 minutes or until the edges become golden brown. Remove from the pan and place on a paper towel–lined plate.

In a medium bowl, whisk ½ **cup of crème fraîche** until it is creamy.

Assemble a serving by laying down **a couple of pieces of lettuce** per serving. Top with the chicken and red onion mixture, followed by a dollop of crème fraîche and a sprinkle of the rye bread crumbs. Add more **fresh tarragon** for garnish. Repeat for additional servings or store the leftover ingredients in an airtight container in the fridge up to 3 days to assemble later.

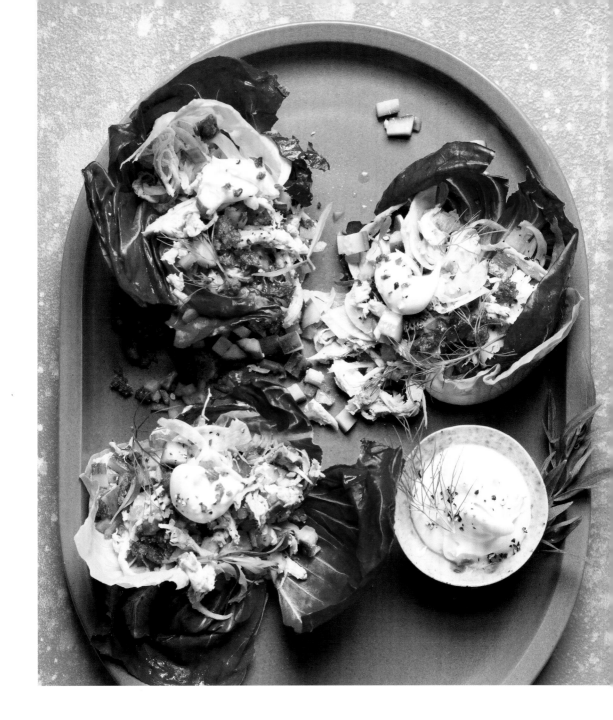

Quinoa Fritters with Kale and Goat Cheese

Healthy, Tangy, Crunchy

MAKES ABOUT 10 PATTIES

In a large skillet, warm **2 tablespoons of neutral oil** over medium heat. Add **1 diced onion, a pinch of salt,** and **a pinch of black pepper** and sauté until the onion is soft, 4 to 6 minutes. Stem and finely chop **1 bunch of kale**, add to the skillet, and cook for 2 minutes, until wilted. Add **2 minced cloves of garlic, 1 teaspoon of ground cumin,** and **1 teaspoon of smoked paprika** and sauté for 30 seconds. Transfer to a large bowl. Add **2 ½ cups cooked quinoa, a large pinch of salt,** and **a pinch of black pepper** and mix well.

In a small bowl, whisk together **3 eggs**. Fold the eggs into the quinoa mixture, followed by **¾ cup of dried bread crumbs** and **½ cup of crumbled soft goat cheese**. Make patties with ⅓-cup tightly packed quinoa mixture. Place on a plate and refrigerate for about 20 minutes.

In the large skillet, warm **2 tablespoons of neutral oil** over medium heat. Working in batches, cook the patties for 12 to 14 minutes, flipping halfway through, until golden brown.Serve with a dollop of **cucumber yogurt sauce** (page 216).

TIP Leftover quinoa works best since it is dry and can absorb the egg better.

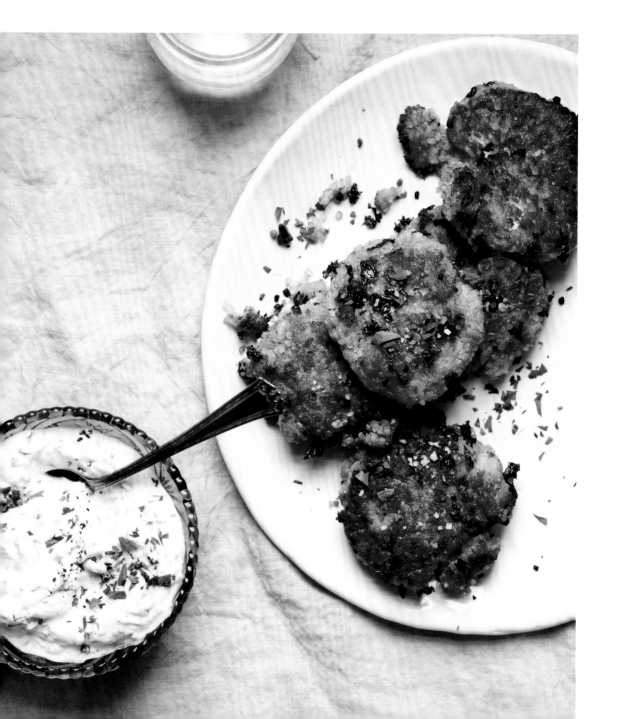

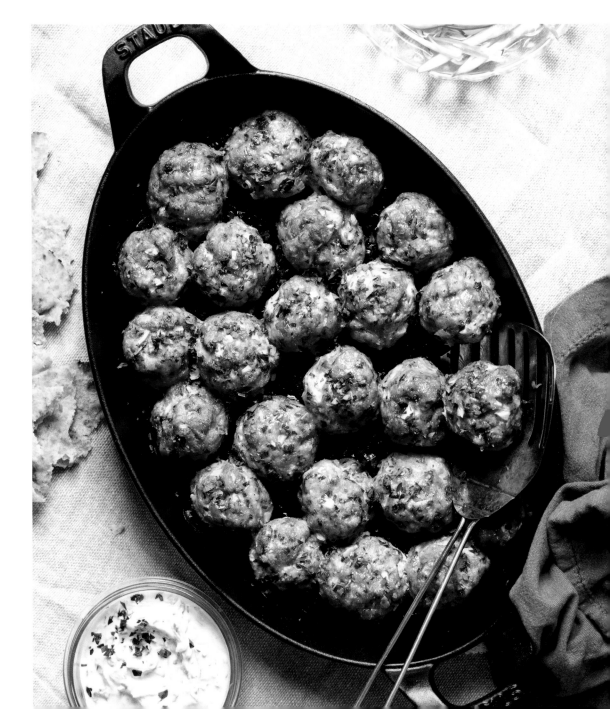

Herby Turkey Meatball Pitas

Herbaceous, Light, Fresh

SERVES 4

Preheat the oven to 425°F. Place a large cast-iron skillet or roasting pan in the oven while it preheats.

Warm **2 tablespoons of olive oil** in a large skillet over medium-high heat. Add **1 thinly sliced onion** and **a pinch of salt** and sauté until soft, 4 to 6 minutes. Add **2 teaspoons of minced garlic**, **1 teaspoon of ground cumin**, **1 teaspoon of ground coriander**, and **a pinch of red pepper flakes** and cook, stirring, until fragrant, 60 seconds. Let cool slightly in a large bowl.

Pulse **1 cup of fresh parsley leaves** and ½ cup of fresh mint leaves in a food processor, add the onion mixture, and pulse until smooth; return to the bowl. Add **1½ pounds of ground turkey**, ½ cup of **dried bread crumbs**, **a pinch of salt**, and **a pinch of black pepper**. Divide the mixture into 2-inch round meatballs.

Carefully remove the pan from the oven and pour in **2 tablespoons of olive oil**. Add the meatballs in a single layer and roast for 18 to 20 minutes, turning over after 8 minutes, until they reach 165°F on a meat thermometer.

Serve the warm meatballs with a dollop of **cucumber yogurt sauce** (page 216), a warm **pita**, and **pickled onions** (page 220).

SNACKS

AND

BAR BITES

Spicy Coconut Cashews

Salty, Sweet, Spicy

MAKES 2 CUPS

Preheat the oven to 350°F. Line a sheet pan with parchment paper.

In a blender or food processor, process **¾ cup unsweetened coconut flakes** until tiny flakes are formed. Set aside.

In a skillet over medium heat, combine **2 tablespoons of coconut oil**, **¼ cup of honey**, **1 teaspoon of light brown sugar**, **2 teaspoons of curry powder**, **1 teaspoon of salt**, and **a pinch of cayenne** (optional). Toss with **2 cups of raw cashews** and the coconut flakes.

Transfer the cashews to the prepared sheet pan and bake for 15 to 20 minutes, until fragrant and just barely golden brown, tossing halfway through. Let the cashews sit for at least 10 minutes before eating. Store at room temperature in an air tight container for up to 2 weeks.

TIPS Make sure to get unsweetened coconut flakes to prevent the cashews from being too sweet. If you can find finely flaked unsweetened coconut, then there is no need to blend at the beginning.

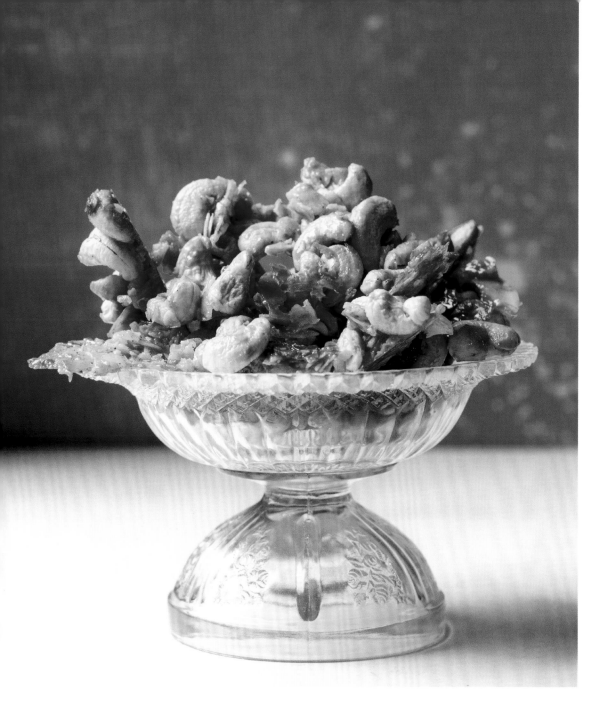

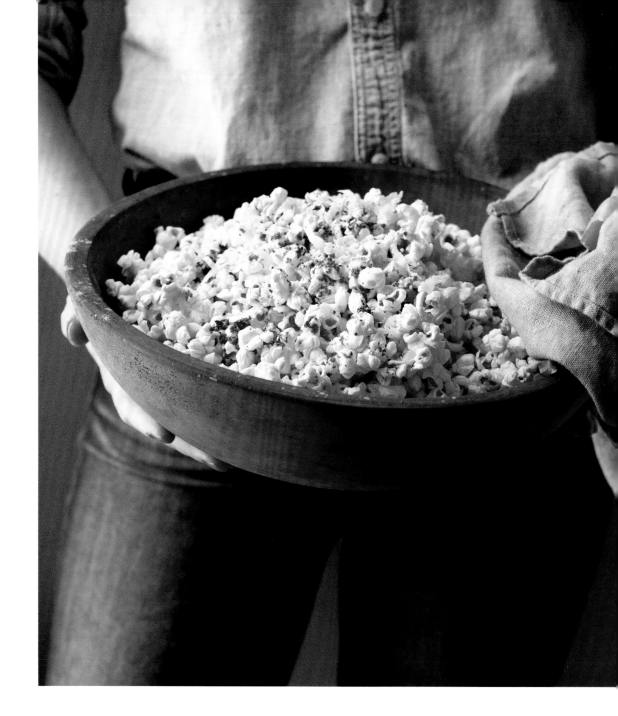

Truffled Popcorn

Savory, Crunchy, Umami

SHOPPING LIST

Porcini powder
Popcorn kernels
Neutral oil
Truffle oil
Butter
Parmesan cheese

MAKES ABOUT 14 CUPS

In a small skillet, melt **4 tablespoons of butter** over medium heat. Stir in **2 tablespoons of porcini powder**. Remove from the heat but keep warm.

In a large pot, warm **2 tablespoons of neutral oil** over medium heat. Add **1 cup of popcorn kernels** and cook, covered, until the kernels have stopped popping. Drizzle in the porcini butter and toss well. Add **2 tablespoons of truffle oil**, **¼ cup of freshly grated Parmesan cheese**, and taste for **salt** and **black pepper**. Serve immediately.

TIPS The porcini powder adds the mushroom flavor to the popcorn while the truffle oil adds just the right amount of truffle. Use truffle oil instead of salt to control the salt levels and simply taste the popcorn for your desired salt amount. To make the porcini powder, process dried porcini mushrooms in a blender on high speed until a powder is formed. Save any excess porcini powder in an airtight container at room temperature for up to a month.

Crunchy Ranch Chickpeas

Crunchy, Savory, Tangy

MAKES ABOUT 1½ CUPS

To make the ranch seasoning, in a small bowl, combine **½ cup of dried buttermilk powder, 1 tablespoon of dried parsley, 2 teaspoons of dried dill, 1 teaspoon of dried chives, 1 tablespoon of garlic powder, 1 tablespoon of onion powder, 1 teaspoon of salt**, and **½ teaspoon of black pepper**. Mix well.

Drain **1 (15-ounce) can of chickpeas** and spread out on a sheet pan. Carefully remove the skins of the chickpeas and let air-dry for about 30 minutes.

Preheat the oven to 350°F.

Toss the chickpeas with **1 tablespoon of olive oil** followed by **3 tablespoons of the ranch seasoning**. Spread out in a single layer on a sheet pan and bake for 35 to 40 minutes, until crispy.

Taste for **salt** and serve immediately or store in an airtight container at room temperature for up to a week.

TIP This makes more seasoning mix than you need. Store the extra seasoning in an airtight container at room temperature until you are ready to make another batch of the chickpeas.

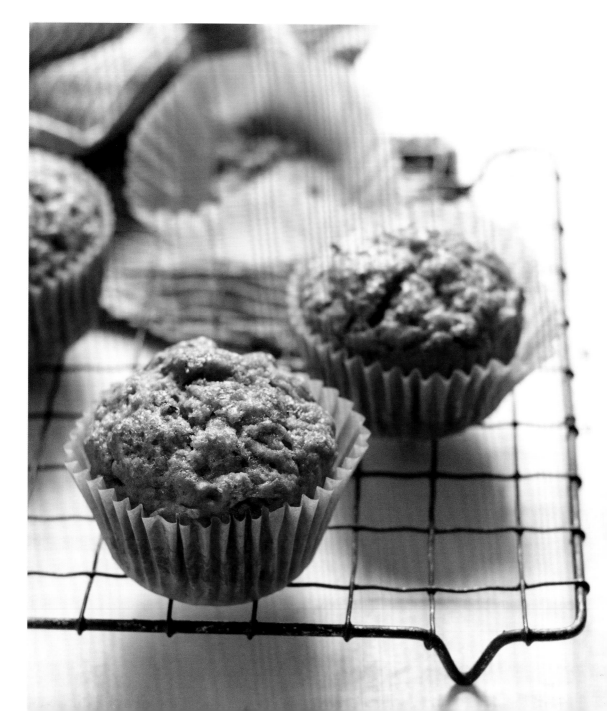

Zucchini Banana Muffins

Filling, Satisfying, Comforting

SHOPPING LIST

Flour

Cinnamon

Baking soda

Baking powder

Light brown sugar

Coconut oil

Vanilla extract

Banana

Zucchini

Eggs

MAKES 12 MUFFINS

Preheat the oven to 350°F. Line a 12-cup muffin pan with paper liners and spray lightly with nonstick cooking spray.

In a small bowl, whisk to combine **2 cups of flour**, **1 teaspoon of ground cinnamon**, **½ teaspoon of baking soda**, **½ teaspoon of baking powder**, and **½ teaspoon of salt**. Set aside.

In the bowl of a stand mixer fitted with a paddle attachment, beat together **1 mashed banana**, **½ cup of melted coconut oil**, **½ cup of packed light brown sugar**, and **1 teaspoon of vanilla extract**. With the mixer on low, slowly add **2 eggs**, one at a time, followed by **2 cups of shredded zucchini** that has had the water gently squeezed out.

Add the dry ingredients to the wet ingredients and mix until just barely combined. Spoon into prepared muffin pan. Bake for 22 to 25 minutes, until a toothpick inserted into a muffin comes out clean.

Let cool slightly before serving. Store at room temperature in an airtight container for up to 3 days or freeze in a plastic bag up to a month. Reheat in the microwave, 15 to 30 seconds.

TIP These also work really well for a quick on-the-go breakfast or snack.

SHOPPING LIST

Halved cashews

Vanilla extract

Apricot preserves

Fresh diced
mango chunks

Greek yogurt

Frozen Yogurt Bark

Creamy, Cold, Refreshing

SERVES 4 TO 6

Line a sheet pan with parchment paper.

In a bowl, mix together **2 cups of full-fat plain Greek yogurt**, **3 tablespoons of apricot preserves**, **1 teaspoon of vanilla extract**, and **a pinch of salt**. Using an offset spatula, spread the yogurt mixture on the prepared sheet pan. Top with **1 cup of diced mango** and **⅓ cup of halved cashews**. Cover with plastic wrap and freeze until firm, at least 4 hours, or preferably overnight.

Remove from the freezer, break into pieces, and eat immediately. Store in a freezer-safe container for up to 2 weeks.

TIPS For an extra-special treat, place a piece of the bark between two graham crackers. Feel free to use other combinations of toppings, such as raspberry and hazelnut, or strawberry and almond.

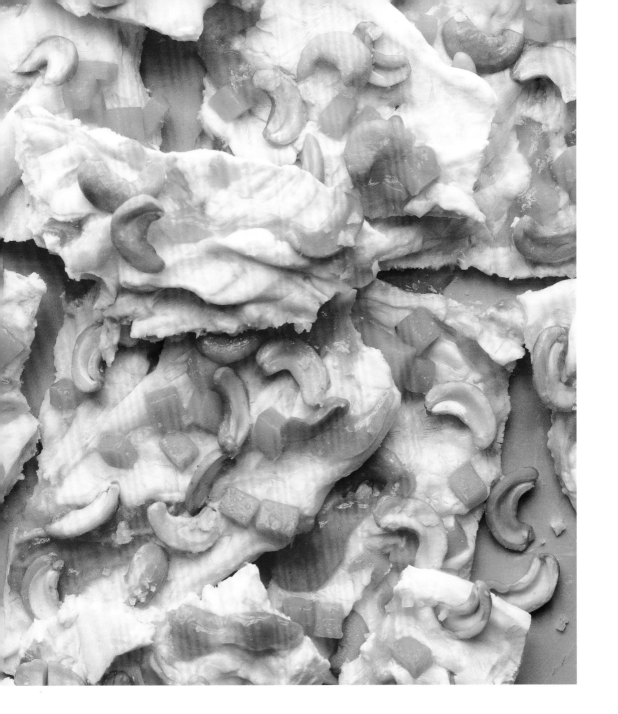

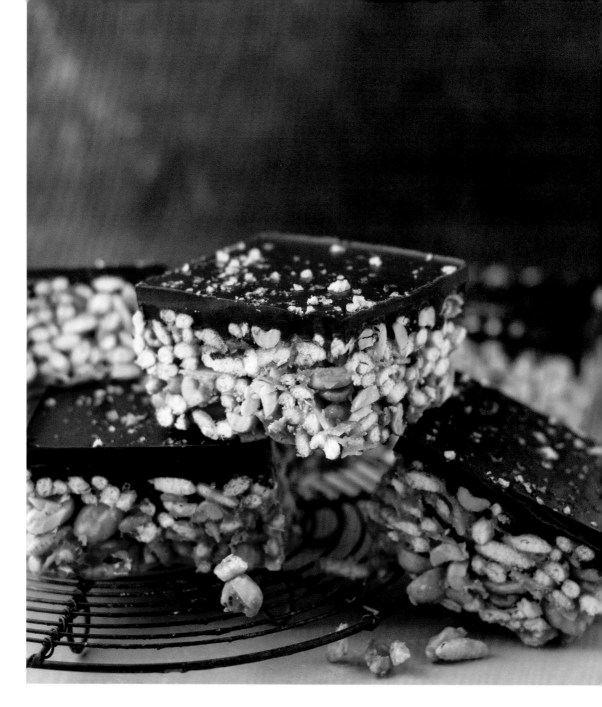

Crispy Rice and Roasted Peanut Bars

Sweet, Savory, Hearty

SHOPPING LIST

Puffed rice cereal

Unsweetened toasted coconut flakes

Unsalted roasted peanuts

Coconut oil

Honey

Vanilla extract

Peanut butter

Semisweet chocolate

MAKES ABOUT 8 BARS

Line an 8 by 8-inch baking dish with parchment paper, letting the paper overhang on the sides.

In a large bowl, mix together **3 cups of puffed rice cereal, 1 cup of unsweetened toasted coconut flakes**, and **1 cup of unsalted roasted peanuts**.

In a small skillet over medium heat, whisk together **2 tablespoons of coconut oil**, ½ **cup of honey**, ½ **cup of peanut butter**, ½ **teaspoon of salt**, and **1 teaspoon of vanilla**.

Pour the mixture over the puffed rice mixture and mix well. Press the mixture into the prepared baking dish.

In a double boiler or microwave, melt **8 ounces of semisweet chocolate**. Spread the chocolate over the puffed rice mixture and sprinkle on some **flaky sea salt**. Refrigerate until chilled, about an hour. Cut into bars and serve.

Store covered in the refrigerator for up to a week.

TIPS You can swap out toasted unsalted almonds and almond butter for the peanuts and peanut butter. Feel free to skip the chocolate if you prefer.

Orange and Almond Paste–Stuffed Dates

Sweet, Bright, Filling

MAKES ABOUT 40 DATES

Pulse **1½ cups sliced almonds** in a food processor until they have the consistency of coarse sand.

Bring ⅓ **cup of honey, 1 teaspoon of finely grated orange zest**, and **a pinch of salt** to a boil over medium heat. With the food processor running, pour in the honey mixture and pulse until a thick paste forms.

Using a spoon or your fingers, insert about 1 teaspoon of the almond paste into the centers of **40 pitted dates**. Sprinkle with **flaky sea salt** and serve immediately, or store in an airtight container at room temperature for up to 2 weeks.

TIPS Both the dates and the almond paste will keep at room temperature in case you don't want to make all 40 dates at one time. If you don't want to bother with the almond paste, you can stuff the dates with unsweetened almond butter, but don't forget the sprinkle of sea salt on top; it adds the salty balance needed for sweet dates.

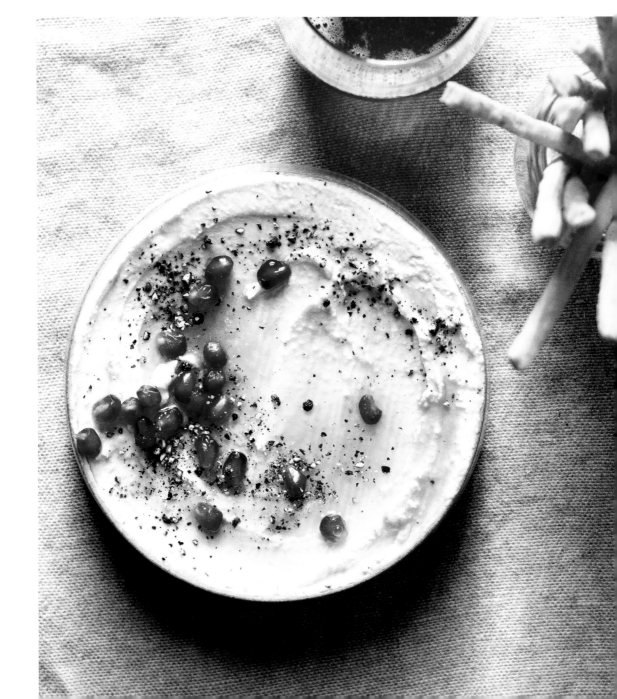

Whipped Feta with Honey, Black Pepper, and Pomegranate Seeds

Salty, Creamy, Sweet

SHOPPING LIST

Honey

Pomegranate
seeds

Feta cheese

Heavy cream

Crackers (optional)

Vegetables
(optional)

SERVES 4 TO 6

In a food processor, combine **12 ounces of feta cheese** and **2 tablespoons of heavy cream** and process until the cheese is smooth and creamy, stopping to scrape the sides of the bowl, if necessary.

Scoop the whipped feta into a large shallow bowl and top with a **drizzle of honey**, **a sprinkle of black pepper**, and **pomegranate seeds**. Serve with **crackers** or **vegetables**.

TIPS This dip would go really well with a crudité plate. The feta and cream may look dry when pulsed together but continue pulsing until creamy. The dip is best right when made, but if the mixture starts to become liquidy, throw it in the fridge for a couple of minutes to firm up.

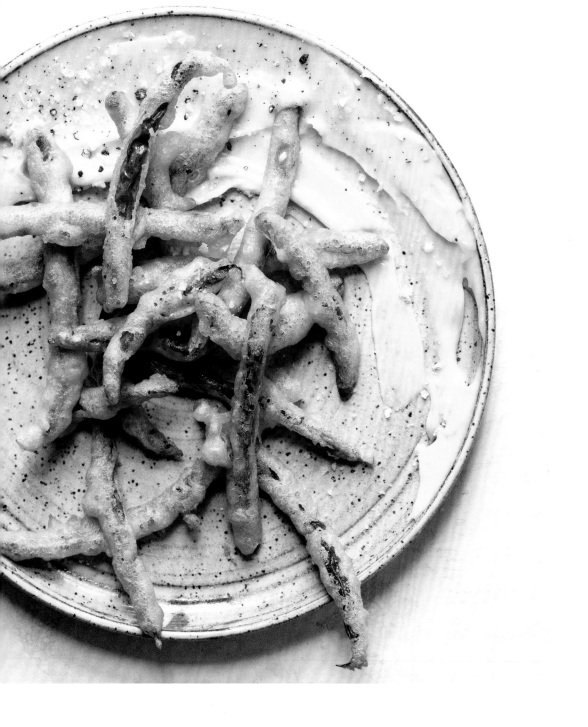

Tempura Green Beans with Wasabi Dipping Sauce

Crunchy, Satisfying, Salty

SERVES 4 TO 6

Heat **3 inches of neutral oil** in a Dutch oven over medium-high heat to 375°F.

Whisk together **½ cup of mayonnaise** and **¼ cup of wasabi powder**, or more or less depending on your personal spice preference. Set aside.

In a large bowl, whisk together **1¼ cups of flour**, **1½ cups of club soda**, and **2 teaspoons of salt**. Trim **1 pound of green beans** and coat in the flour mixture. Working in batches, carefully place some of the beans into the oil and fry for about 3 minutes, until golden brown. Remove from the oil with a slotted spoon and sprinkle with **salt** and **pepper**. Repeat with the remaining green beans and serve with the dipping sauce. Eat immediately.

TIP Wasabi powder can be found at most grocery stores. Also check for wasabi paste if powder can't be found. I am a wimp when it comes to spicy things, but feel free to add as much wasabi as you want to the dipping sauce.

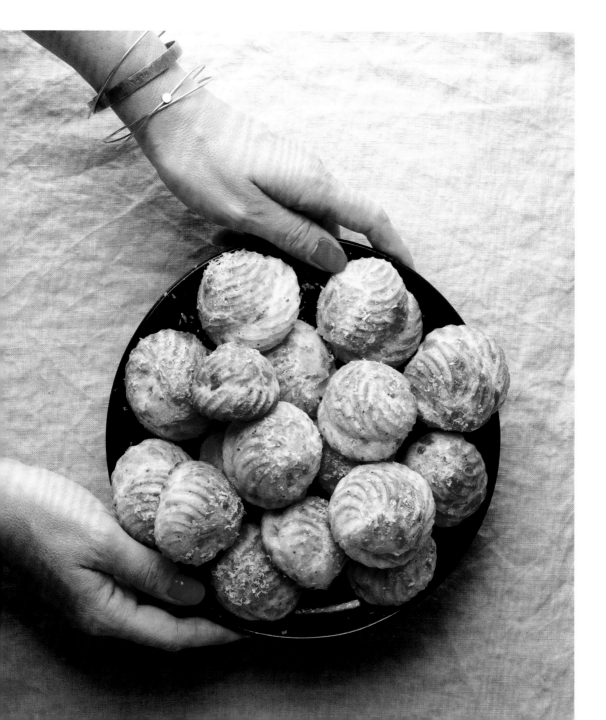

Black Pepper Gougères

Light, Addictive, Comforting

SHOPPING LIST

Flour

Eggs

Whole milk

Butter

Gruyère cheese

Parmesan cheese

MAKES 35 TO 40

Preheat the oven to 350°F. Line a sheet pan with parchment paper.

Combine **½ cup of water**, **½ cup of whole milk**, **½ cup of butter**, and **½ teaspoon of salt** in a saucepan. Bring to a boil, making sure the butter is melted. Turn down the heat to low and, with a wooden spoon, vigorously stir in **1 cup of flour**. Continue stirring until the mixture forms a ball and the bottom of the pan is left with a film of the mixture. Remove from heat and let cool for 5 minutes.

Transfer the dough to a stand mixer fitted with a paddle attachment and add in **4 eggs**, one at a time, beating on low until each egg is incorporated. Fold in **1 cup of finely grated Gruyère cheese** and **1 teaspoon of black pepper**. Using two spoons or a piping bag, place mounds of about 2 tablespoons of the dough onto the prepared sheet pan about 1 inch apart. Sprinkle with **freshly grated Parmesan cheese** and **more black pepper**.

CONTINUED

Black Pepper Gougères

CONTINUED

Bake for 30 to 35 minutes, until the gougères are golden brown. Serve immediately or let cool, then store in an airtight container at room temperature for up to 3 days. When ready to serve them, place them on a sheet pan and reheat in the oven for about 5 minutes before serving.

TIP The pâte à choux pastry that the gougères are made from can sometimes be hard to pipe or spoon out. Smooth the top of each to make them round by dipping your finger in water, then gently patting the gougère into place.

Riffs on a Party Platter

Who doesn't love a party platter overflowing with a bunch of delicious options? It's lots of finger food that makes for great mingling.

Combine the following onto one huge platter. Make sure to plate it with a couple of knives and some paper napkins and let everyone dig in.

Black
Pepper Gougères
(page 111)

Everything
Bagel–Seasoning
Phyllo Crackers
(page 114)

Thinly sliced
salami and
cured meats

An array of cheeses, such as a soft cheese like
fresh goat cheese drizzled with a little honey,
a medium-firm cheese like an aged cheddar,
and a hard cheese like Parmesan

Fresh and
dried fruit

SHOPPING LIST

Phyllo dough

Everything bagel
seasoning

Egg

Butter

Everything Bagel–Seasoning Phyllo Crackers

Salty, Crunchy, Savory

MAKES ABOUT 28 CRACKERS

Preheat the oven to 375°F. Line both a sheet pan and a cutting board with parchment paper.

Remove the **phyllo dough from a 1-pound package**. Cut in half crosswise. Save half for another use. There should be about 14 layers of phyllo.

In a small bowl, mix together **6 tablespoons of melted butter** and **1 whisked egg**. Place 1 piece of phyllo on the prepared cutting board. Using a pastry brush, lightly brush with the butter mixture. Place a piece of phyllo on top and repeat the process of brushing and layering with the remaining phyllo, brushing the top layer.

Sprinkle the top with **3 tablespoons of everything bagel seasoning**. Cut into approximately 1 by 2-inch rectangles and transfer to the prepared sheet pan.

Bake for 13 to 15 minutes, or until golden brown. Eat warm or at room temperature. Store the crackers at room temperature for up to 3 days in an airtight container.

TIP Everything bagel seasoning can be found at most groceries stores. If you can't find it, make your own with salt, dried onion, and sesame seeds.

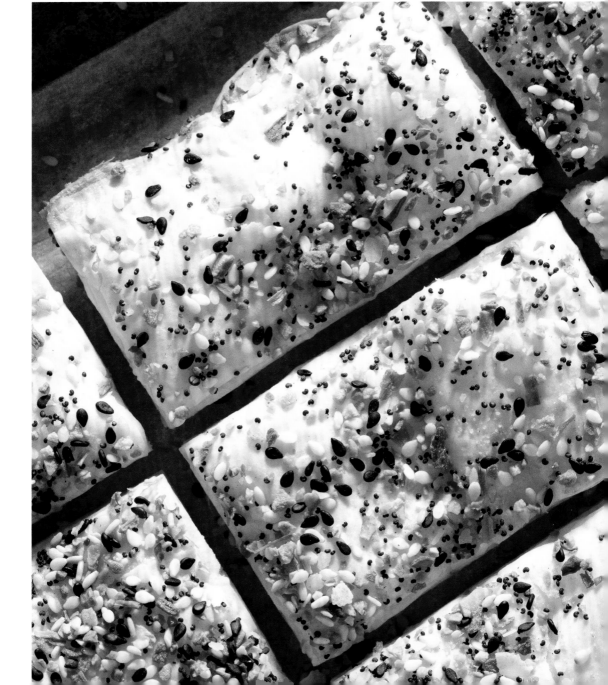

PANTRY

PASTAS

Parsley Pesto Pasta with Chickpeas and Ricotta Salata

Herbaceous, Fresh, Bright

SERVES ABOUT 4

To make the pesto, combine **1 cup of fresh parsley leaves, 1 cup of fresh basil, 2 tablespoons of pine nuts, 2 cloves of garlic, a pinch of salt**, and **a pinch of black pepper** in a food processor. Pulse until the mixture is finely minced. With the motor running, drizzle in **½ cup of olive oil** and continue running until the mixture is smooth. Add **½ cup of freshly grated Parmesan cheese** and pulse just until it is combined. Set aside.

Cook **12 ounces of dried pasta** according to the package instructions. Drain, saving ¼ cup of the pasta cooking liquid. In the same pot, warm **2 tablespoons of olive oil** over medium-high heat. Drain and add **1 (15-ounce) can chickpeas** along with **a pinch of salt** and **a pinch of black pepper**. Cook the chickpeas for 2 to 3 minutes, until they become golden brown and slightly crispy. Add the cooked pasta, as well as all of the pesto and the **juice of 1 lemon**. Toss well, drizzling in some of the reserved pasta liquid to thin out the pesto, if needed. Top with **¼ cup of crumbled ricotta salata** and taste for **salt** and **pepper**. Serve warm.

TIP For topping, Parmesan cheese will work instead of ricotta salata.

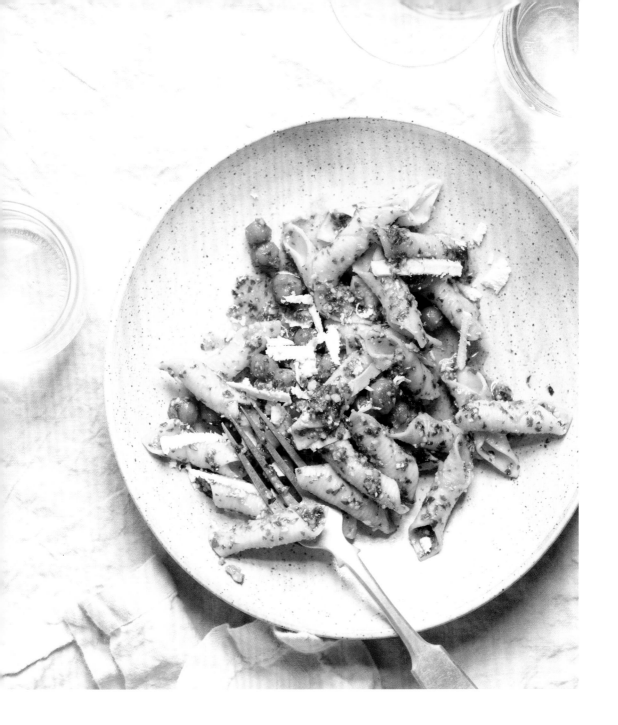

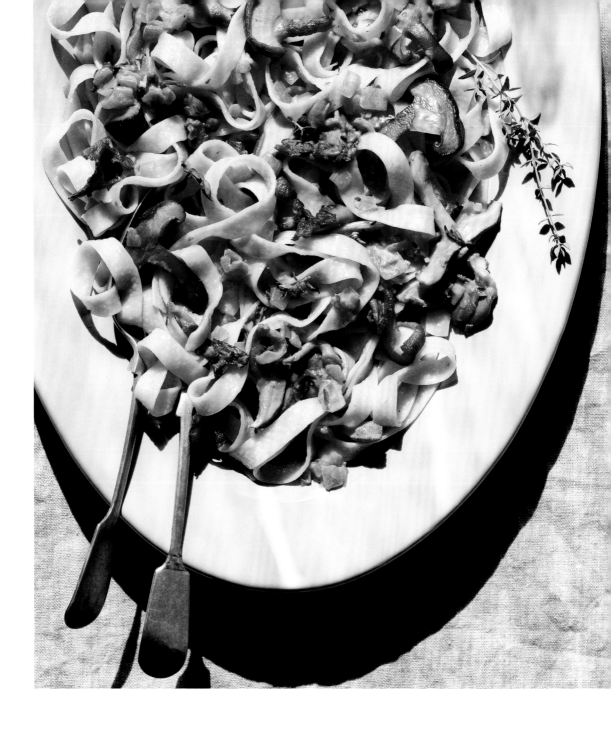

Tagliatelle with Creamy Mushroom Ragu

Creamy, Umami, Vegetarian

SHOPPING LIST
Tagliatelle pasta
Olive oil
Vegetable stock
Onion
Garlic
Mushrooms
Fresh thyme
Heavy cream
Marsala wine

SERVES ABOUT 4

In a large skillet, warm **2 tablespoons of olive oil** over medium heat. Add **1 diced onion** and sauté until translucent and soft, 4 to 6 minutes. Add **2 minced cloves of garlic** and cook for another 30 seconds. Increase the heat to high, add **1 pound of sliced assorted mushrooms** and **1 tablespoon of chopped fresh thyme**, and sauté for 8 to 10 minutes, until the mushrooms are soft and all of the liquid has evaporated. Deglaze with **½ cup Marsala wine**. Add **1⅓ cups vegetable stock** and cook for about 30 minutes, until the liquid has reduced by half. Stir in **2 tablespoons of heavy cream** and taste for **salt** and **pepper**.

While the sauce is cooking, prepare **12 ounces of tagliatelle pasta** according to the package instructions. Drain and toss the cooked pasta with the mushroom sauce. Serve warm.

TIPS The heavy cream added to the ragu at the end adds a bit of decadence, but feel free to skip it and make this a vegan pasta dish. Use any type of pasta that you like if you don't have tagliatelle.

Pasta with Artichokes, Basil, and Brown Butter

Fresh, Light, Springlike

SERVES ABOUT 4

To make the brown butter, in a small skillet, melt **8 tablespoons of butter** over medium-low heat. Continue heating until the milk fat separates from the butter and turns a golden brown color. Remove from the heat and pour into a small bowl. Set aside, but keep warm.

Cook **12 ounces of pasta** according to the package instructions. Drain and set aside but keep warm.

In a large skillet, warm **2 tablespoons of olive oil** over medium heat. Add ½ **diced onion** and sauté until translucent, 4 to 6 minutes. Add **2 minced cloves of garlic** and saute for another 30 seconds. Add **1 (15-ounce) can of drained artichokes**, and continue cooking for another 4 to 6 minutes or until the edges of the artichokes start to brown. Deglaze the pan with ½ **cup of white wine**. Cook until the wine is reduced by half. Add the finely grated zest of **1 lemon** and **1 cup of fresh basil leaves**. Add the pasta into the pan and mix well. Drizzle the pasta with brown butter and a large pinch of flaky sea salt, and serve.

TIP This makes more brown butter than you need for this recipe. You can store the extra brown butter in the fridge for up to 2 weeks. Drizzle it over roasted vegetables, risotto, or roast chicken.

Riffs on Leftover Bread

Make it savory or even sweet.

→ **MAKE BREAD CRUMBS** Pulse **dry cubes of old bread** in a blender or food processor. Store in the freezer and consider using some of the bread crumbs to make the Orange Bread Crumb Cake on page 190.

→ **MAKE BREAD PUDDING** Store stale bits and pieces of leftover bread in the freezer until you have about **8 cups of bread**. Defrost, then make the bread pudding by combining **4 cups of half-and-half** with **6 eggs** and **¾ cup of sugar**. Add **a dash of vanilla extract**, **some finely grated orange zest**, and **a pinch of salt**. Toss with the dried bread and let it soak overnight. Fold in **a couple of handfuls of berries** and bake at 350°F, covered with aluminum foil, for 45 minutes. Remove the foil and bake until top is golden brown and filling is set, about 20 minutes.

→ **MAKE PANZANELLA** Toast **old bread pieces**. Toss in a big bowl with all of your favorite **salad vegetables**, **some creamy cheese** like fresh mozzarella, and **a big drizzle of a vinaigrette**.

→ **MAKE A STRATA** Follow the same directions as the bread pudding but replace the sugar, vanilla extract, orange zest, and berries with **a couple of large handfuls of shredded cheese** of your choice and add some **caramelized onions** (page 227) for extra flavor.

→ **MAKE AN EGG & TOAST CUP** Flatten **4 slices of bread** with a rolling pin or your hands. Fit the slices into the cups of a muffin pan. Bake at 400°F for 5 minutes. Remove and crack **an egg** into each of the bread cups. Return to the oven and bake for another 12 to 14 minutes, or until you reach your desired egg doneness.

→ **MAKE RIBOLLITA** Sauté **onion**, **carrot**, **celery**, **tomatoes**, and **kale** until the vegetables are soft. Add in **some stock** and a leftover **Parmesan cheese rind** and simmer for 15 minutes. Stir in **white beans,** then top with **leftover bread**. Sprinkle **shredded cheese** on top and pop in the broiler until melted.

SHOPPING LIST
Spaghetti
Anchovy paste
Garlic
Beefsteak tomato
Cherry tomatoes
Fresh herbs
Butter

Grated Fresh Tomato Spaghetti with Anchovies

Salty, Light, Satisfying

SERVES ABOUT 4

Cook **12 ounces of dried spaghetti** according to the package instructions. Drain the pasta but save ½ cup of the cooking water.

In a large skillet, melt **4 tablespoons of butter** over medium heat. Add **1 tablespoon of anchovy paste** and **2 minced cloves of garlic** and sauté for 30 seconds, or until the garlic is browned and the anchovy melts into the butter. Add **1 grated beefsteak tomato**, **a large pinch of salt**, and **a pinch of black pepper**. Cook for 1 to 2 minutes, or until the sauce comes together. Add the cooked pasta and the reserved cooking liquid and toss until all of the pasta is coated with the sauce. Fold in **1 pint of cherry tomatoes, halved if large,** and cook only until warmed through. Taste for **salt** and **pepper** and serve topped with **a large handful of coarsely chopped fresh herbs**, such as basil and chives.

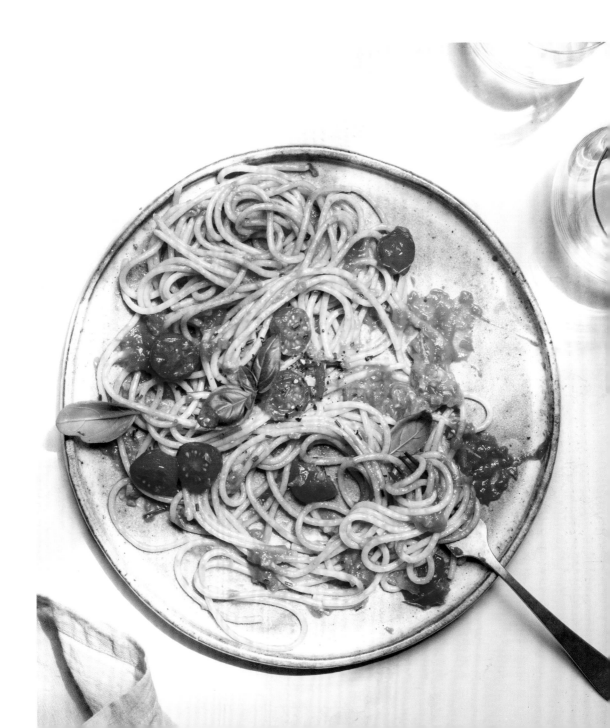

Penne with Rotisserie Chicken and Smoky Tomato Sauce

Smoky, Sharp, Filling

SERVES 4

Cook **12 ounces of penne pasta** according to the package instructions. Drain and set aside.

In the same pan, warm **2 tablespoons of olive oil** over medium heat. Add **1 diced onion** and sauté for 4 to 6 minutes, until soft. Add **2 minced cloves of garlic** and sauté for another 30 seconds.

Add **1 (28-ounce) can of plum tomatoes, ½ teaspoon liquid smoke flavor** (optional), **½ cup heavy cream, 4 tablespoons of butter, a large pinch of salt**, and **a pinch of black pepper** and cook for about 20 minutes, or until the sauce is reduced by half. Fold in the **coarsely chopped meat of 1 whole rotisserie chicken** and cook until warmed through. Toss with the pasta and serve with **freshly grated Parmesan cheese.**

TIP The liquid smoke in this recipe is optional but is well worth it, if you have it in your pantry. Available at most grocery stores, it will add a smoky flavor to this pasta as well as to other meats and vegetables. Liquid smoke is made by the condensation from flavorful burning wood, such as hickory, and combined with water.

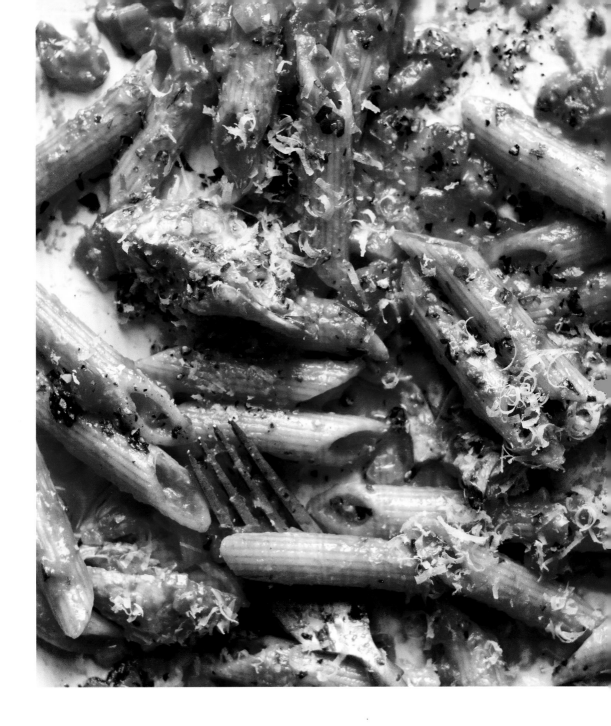

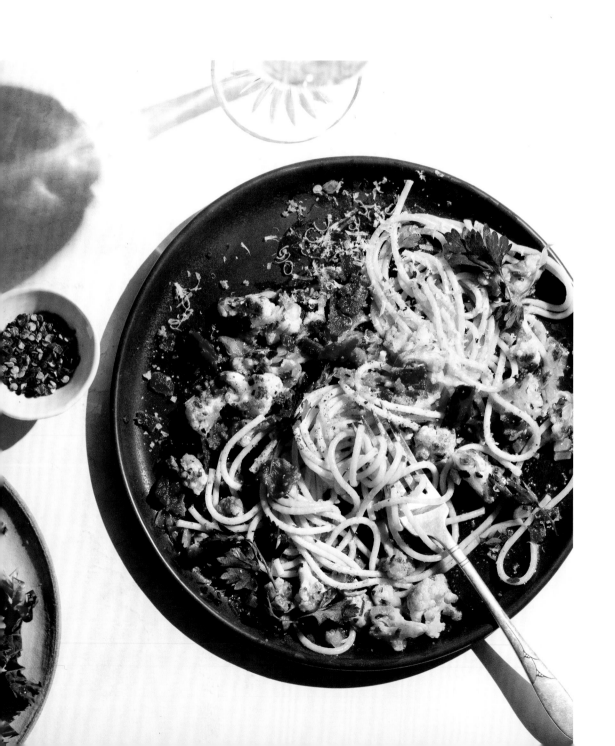

Bucatini with Cauliflower and Bacon

Salty, Rich, Hearty

SERVES ABOUT 4

SHOPPING LIST
Bucatini pasta
Dried bread
crumbs
Red pepper flakes
Olive oil
Onion
Cauliflower
Lemon
Fresh parsley
Parmesan cheese
Bacon

Cook **12 ounces of bucatini** according to the package instructions. Drain but save ½ cup of the pasta cooking liquid.

In a large skillet, warm **1 tablespoon of olive oil** over medium heat. Dice **4 strips of thick-cut bacon**, add to the skillet, and cook for 4 to 6 minutes, until crispy. Transfer to a paper towel–lined plate and pour off all but about 2 tablespoons of the bacon fat.

Add ½ **diced onion** and **the florets of 1 whole cauliflower**. Mix well, cover, and cook for 10 minutes over medium-low heat. Uncover and cook for 8 to 10 minutes, until fork tender. Deglaze with the **juice of 1 lemon**. Add the cooked pasta and reserved pasta cooking liquid. Mix in ½ **cup of freshly grated Parmesan**.

In a small skillet, cook ¼ **cup of dried bread crumbs**, the reserved bacon fat, the **finely grated zest of 1 lemon**, and **a pinch of red pepper flakes** over medium heat, until crisp, 2 to 4 minutes.

Serve the pasta topped with the bread crumbs, crumbled bacon, **chopped fresh parsley**, and **more Parmesan cheese**.

TIPS To make this vegetarian, skip the bacon and add caramelized onions (page 227). If you can't find bucatini, just use a type of pasta that you like.

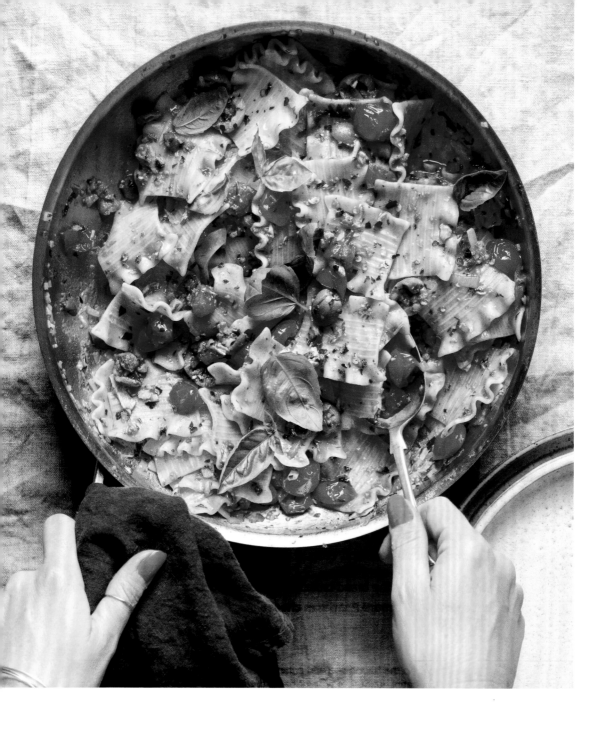

Pasta with Tuna, Castelvetrano Olives, and Blistered Cherry Tomatoes

Salty, Balanced, Chewy

SHOPPING LIST
Pasta
Red pepper flakes
Olive oil
Castelvetrano olives
Shallot
Garlic
Cherry tomatoes
Fresh basil
Parmesan cheese
Canned tuna

SERVES ABOUT 4

Cook **12 ounces of dried pasta** according to the package instructions. Drain, rinse with cool water, and set aside.

In the same pan, warm **2 tablespoons of olive oil** over medium heat. Add **1 minced shallot**, **2 minced cloves of garlic**, and **3 cups of cherry tomatoes** and sauté, covered, for about 15 minutes, until the tomatoes are blistered and soft. Toss the cooked pasta with the tomatoes, along with **½ cup of pitted and thinly sliced Castelvetrano olives** and **5 ounces of drained canned tuna**. Garnish with **fresh basil**, **freshly grated Parmesan cheese**, and **red pepper flakes**.

TIP Cut cherry tomatoes in half if they are large.

WEEKNIGHT

EATS

Zucchini and Eggplant Flatbread

Umami, Peppery, Fresh

MAKES 2 FLATBREADS

Preheat the oven to 400°F.

Pierce **1 medium-size eggplant** a few times with a knife. Roast on a sheet pan for 35 to 40 minutes, until soft. Let cool slightly, then scoop out the eggplant flesh into a food processor. Stir in **1 tablespoon of white miso paste**, **a pinch of salt**, and **a pinch of black pepper**.

While the eggplant is roasting, warm **2 tablespoons of olive oil** in a skillet over medium heat. Add **1 thinly sliced onion** and sauté until soft and translucent, 4 to 6 minutes. Add **2 minced cloves of garlic** and sauté for another 30 seconds. Transfer the onion and garlic mixture to the food processor. Pulse for 15 to 20 seconds, until the eggplant mixture is smooth. Taste for **salt** and **black pepper**, and keep warm.

Preheat a grill pan.

Divide a **1-pound ball of store-bought pizza dough** into two pieces. Roll out each piece into an oval about 10 inches long and 4 inches wide. Place a flatbread on the preheated grill pan and cook until lightly grilled and cooked through, 5 to 7 minutes, flipping halfway through. Repeat with the other round of dough.

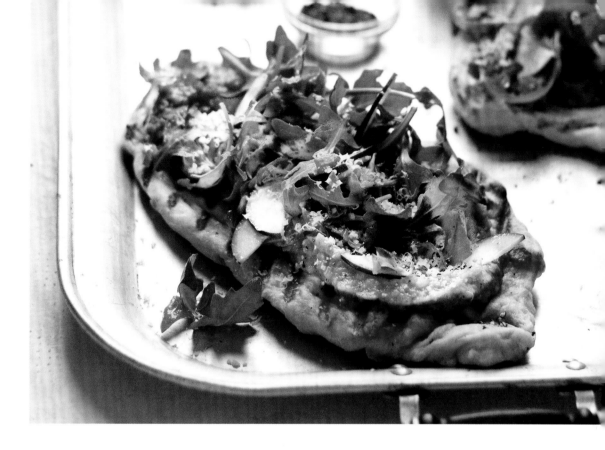

In a small bowl, toss to combine **2 cups of arugula** and **1 thinly sliced zucchini**. Drizzle with **1 tablespoon of olive oil, the juice of ½ lemon, a pinch of salt, a pinch of black pepper**, and **¼ cup of freshly grated Parmesan cheese**.

Top each flatbread with half of the eggplant mixture, followed by half of the arugula-zucchini mixture. Serve immediately.

TIPS If you don't have a grill pan, brush the flatbreads with a little olive oil, then throw the flatbreads on a sheet pan and bake at 425°F until golden brown. White miso paste can be found at most grocery stores in the refrigerated section.

Golden Cauliflower Soup with Toasted Pine Nuts

Earthy, Sweet, Soothing

SHOPPING LIST

Pine nuts

Curry powder

Olive oil

Vegetable stock

Onion

Cauliflower

Apples

Micro greens

SERVES 4

In a large Dutch oven, warm **2 tablespoons of olive oil** over medium heat. Add **1 thinly sliced onion**; **1 whole cauliflower cut into florets**; **2 peeled, cored, and diced apples**; **a pinch of salt**; and **a pinch of black pepper**. Stir well, cover, and cook over low heat for 35 to 45 minutes, until the vegetables are falling apart. Stir in **1 teaspoon of curry powder** and cook for another 30 seconds. Add **1 cup of vegetable stock** and continue cooking, uncovered, for another 10 minutes.

Combine the cauliflower mixture and **1½ cups of vegetable stock** in a blender and blend on high until smooth, adding **more vegetable stock** if needed to thin out the soup to desired consistency. Return the soup to a clean Dutch oven and keep warm.

In a small skillet, toast **¼ cup of pine nuts** over low heat until golden brown, 2 to 4 minutes.

Ladle the soup into four bowls. Top each with pine nuts and **a handful of micro greens**. Serve warm.

TIP The key is to cook down the vegetables until they are almost falling apart. This will make the soup super creamy and smooth when blended.

Turmeric Stew with Spinach and Chickpeas

Earthy, Bitter, Filling

SERVES 4

In a Dutch oven or heavy pot, warm **2 tablespoons of olive oil** over medium heat. Add **1 thinly sliced onion** and sauté for 4 to 6 minutes, until the onion is soft and translucent. Add **2 teaspoons of ground cumin, 2 teaspoons of ground turmeric, a pinch of red pepper flakes, a big pinch of salt**, and **a pinch of black pepper** and cook for another 30 seconds. Add **1 cup of green lentils** and cook for another 30 seconds, making sure the lentils are well combined with the onion and spice mixture. Add **6 cups of vegetable stock**, bring to a boil, cover, and lower the heat to a simmer. Simmer the lentils for 15 to 20 minutes, until the lentils are soft but still have a bit of a bite. Rinse **1 (15-ounce) can of chickpeas.** Fold in the chickpeas and **6 cups of fresh spinach** and continue to cook until the beans are warmed through and the spinach is wilted, 2 to 3 minutes. Taste for **salt** and **pepper**.

Serve the soup warm, topped with **caramelized onions** (page 227), **roasted walnuts, sour cream**, and **chopped fresh dill**.

TIPS Any leafy green available will work for this recipe. The toppings are what take this stew from good to great so don't skip them.

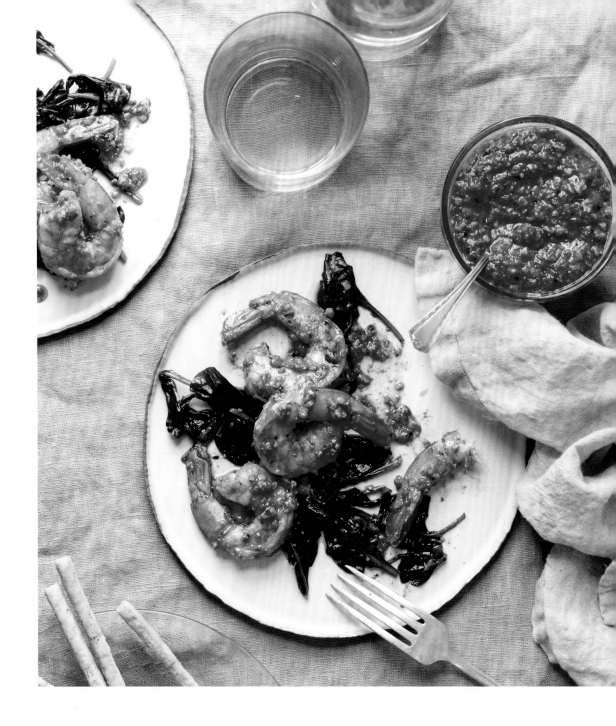

Shrimp in Romesco Sauce with Wilted Spinach

Smoky, Rich, Creamy

SERVES 4

SHOPPING LIST

Olive oil

Fresh spinach

Peeled deveined large shrimp

ROMESCO SAUCE (PAGE 224)

Roasted hazelnuts

Smoked paprika

Olive oil

Roasted red bell peppers

Tomato paste

Red wine vinegar

Fresh parsley

Garlic

Warm **2 tablespoons of olive oil** in a Dutch oven over medium-high heat. Add **1½ pounds of peeled and deveined large shrimp** and sauté until just opaque, about 2 minutes. Add **a large dollop of romesco sauce** (page 224) and cook over low heat for 2 to 3 minutes, or until the shrimp is cooked through and coated with sauce.

Meanwhile, in another pan, warm **2 tablespoons of olive oil**. Add **6 cups of fresh spinach**, working in batches if needed, and sauté over medium heat for 2 minutes, or until the spinach is just barely wilted.

Divide the spinach among four plates and top with the shrimp and **a pinch of salt** and **a pinch of black pepper**. Serve immediately.

TIP Peeled and deveined shrimp can be found in the frozen seafood section at most grocery stores. Simply defrost in the fridge before cooking.

Broiled Halibut with Citrus Salsa

Acidic, Bright, Balanced

SERVES 4

Preheat the broiler. Line a sheet pan with parchment paper.

In a small bowl, combine **1 peeled and diced orange**; **1 peeled and diced grapefruit**; **1 large minced shallot**; **¼ cup coarsely chopped fresh cilantro leaves**; **the zest and juice of 1 lime**; **a pinch of salt**; and **a pinch of black pepper**. Mix well and set aside.

Lay **4 (6-ounce) halibut fillets** skin-side down on the prepared sheet pan. Sprinkle with **salt, pepper, and 1 teaspoon of smoked paprika**. Broil for 8 to 10 minutes, until the tip of a knife can be inserted without any resistance.

Let the halibut rest for 5 minutes. Serve each fillet topped with a spoonful of citrus salsa.

TIP Any thick, neutral-tasting white fish fillet, such as cod, can take the place of the halibut.

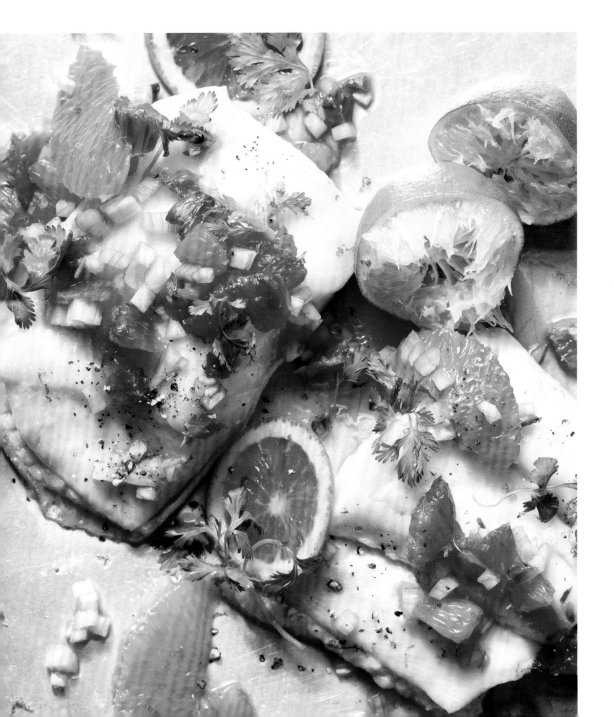

SHOPPING LIST

Smoked paprika
Garlic powder
Dried oregano
Dried thyme
Cayenne pepper
Tortillas
Olive oil
Hot sauce
Tomatillos
Yellow onion
Garlic
Lime
Avocado
Fresh cilantro
Peeled deveined
medium shrimp

PICKLED RED
ONIONS (PAGE 220)
Sugar
Black peppercorns
Bay leaf
Apple cider
vinegar
Red onion
Star anise
(optional)

Shrimp Tacos with Roasted Tomatillo Salsa

Flavorful, Bright, Smoky

SERVES 4

Preheat the oven to 450°F. Line a sheet pan with parchment paper.

To make the seasoning mixture, in a small bowl, combine **1 tablespoon of smoked paprika, 1 teaspoon of dried thyme, 1 teaspoon of dried oregano, 1 teaspoon of garlic powder, 1 teaspoon of salt, ½ teaspoon of black pepper,** and **a pinch of cayenne pepper**. Mix well and set aside.

Combine **1 pound of rinsed and halved tomatillos, ½ coarsely chopped yellow onion,** and **3 cloves of garlic** on the prepared sheet pan. Toss the mixture with **2 tablespoons of olive oil, a large pinch of salt,** and **a pinch of black pepper**. Roast for 13 to 15 minutes, until the tomatillos are soft and the onions have begun to char. Carefully transfer the tomatillo mixture into a blender and blend on medium until slightly chunky. Add the **juice of ½ lime** and taste for **salt**.

Toss **1½ pounds of peeled and deveined medium shrimp** with **2 tablespoons of olive oil** and sprinkle with 1 tablespoon of the seasoning mixture. Spread in an even layer on the same sheet

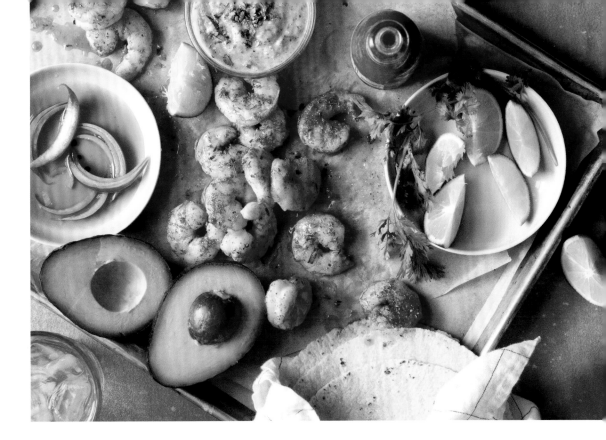

pan and roast for about 5 minutes, until the shrimp are firm and opaque.

Serve the shrimp with **warm tortillas**, **slices of avocado**, **fresh cilantro**, **pickled red onions** (page 220), and your favorite **hot sauce**.

TIPS Save the seasoning mixture in an airtight container at room temperature for up to a month for the next time you make these tacos. Peeled and deveined shrimp can be found in the frozen seafood section at most grocery stores. Simply defrost in the fridge before cooking.

Littleneck Clams with Fennel and Pernod

Salty, Bright, Anise

MAKES ABOUT 4 SERVINGS

In a large bowl, cover **3 pounds of fresh littleneck clams** with cold water and place in the fridge for 20 minutes. Drain.

In a large pot, warm **2 tablespoons of olive oil** over medium heat. Add **½ diced fennel bulb** and sauté until the fennel is soft, 2 to 4 minutes. Add **2 minced cloves of garlic**, **a large minced shallot**, and **a pinch of salt and pepper** and cook for another 30 seconds. Add **¼ cup of Pernod** and cook until reduced by half. Add **3 cups of chicken or vegetable stock**, bring to a boil, and boil until slightly reduced, 3 to 5 minutes. Lower the heat to medium, add **2 tablespoons of butter** and the clams to the pan, cover, and let the clams steam for 4 to 6 minutes, until the clams have opened.

Serve the clams and their broth garnished with **a squeeze of ½ lemon** and **crusty bread**.

TIPS Fresh clams will keep in the fridge for up to 2 days stored in a large bowl covered with a damp paper towel. Do not submerge them in water or store in an airtight container. When initially cleaning the clams in water, watch for any clams that float. That means they are dead; discard them. Discard any that do not open after cooking. Pernod is an anise-flavored liqueur that works really well with the fennel and clams. If you can't find Pernod, replace with another anise-flavored liqueur like ouzo or pastis or skip all together.

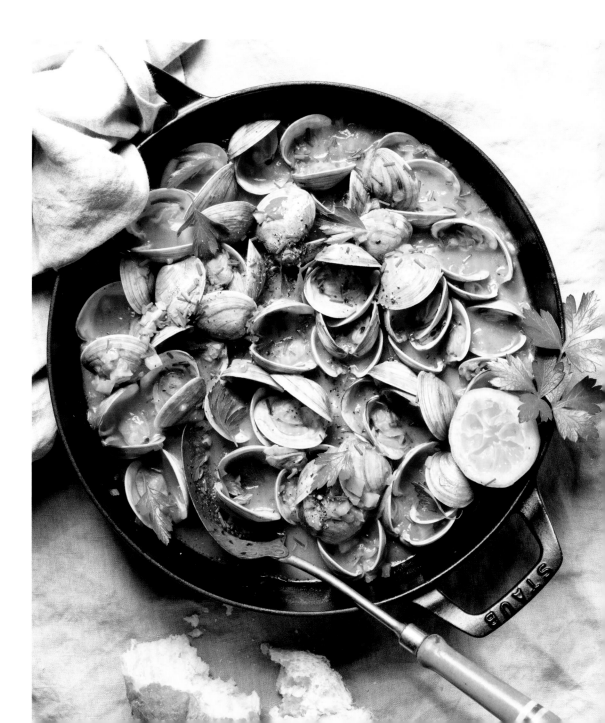

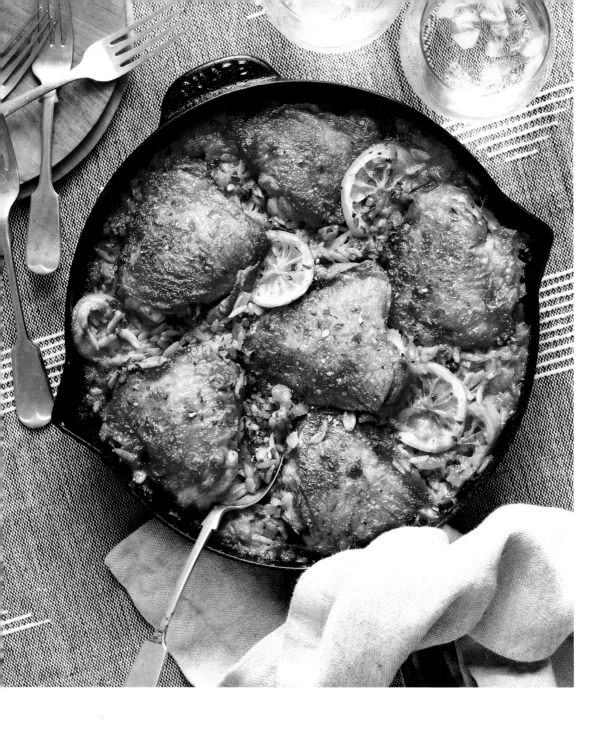

One-Pot Chicken with Orzo and Sun-Dried Tomatoes

Savory, Satisfying, Tangy

SERVES 4

Preheat the oven to 375°F.

Sprinkle **6 bone-in, skin-on chicken thighs** with **a large pinch of salt**. In a large skillet or Dutch oven, warm **2 tablespoons of olive oil** over medium heat. Add the chicken, skin-side down, and brown for 4 to 6 minutes, working in batches as needed. Remove the chicken, carefully draining all but 2 tablespoons of the fat, add **1 diced onion**, and sauté for 4 to 6 minutes, until the onion is soft and translucent. Add **2 minced cloves of garlic** and **a pinch of cracked black pepper**; continue to cook for 30 seconds. Add **1 cup of dried orzo** and **½ cup coarsely chopped sun-dried tomatoes** and sauté for another 30 seconds. Deglaze with **½ cup of white wine** and cook until the liquid is reduced by half. Add **2½ cups of chicken stock** and **½ thinly sliced lemon**. Return the chicken to the pan skin-side up and place the uncovered skillet in the oven. Roast for 35 to 40 minutes, until the chicken is cooked through and the orzo has absorbed the liquid.

Let the chicken sit for 5 minutes before serving.

Dukkah-Crusted Crispy Chicken Cutlet with an Herb Salad

Crunchy, Savory, Satisfying

SERVES 4

Preheat the oven to 450°F. Set a wire rack on a sheet pan.

Gently pound **1 pound of boneless, skinless chicken breasts** with a mallet or rolling pin until ¼ inch thick.

In a large bowl, whisk together **2 egg yolks**, **½ cup of mayonnaise**, and **2 teaspoons of salt**.

In a skillet over medium heat, combine **⅓ cup of olive oil** and **2 cups of panko** and sauté, stirring constantly, until the panko is golden brown, 3 to 5 minutes. Remove from the heat, let cool slightly, then fold in **2 tablespoons or more of pistachio and peanut dukkah** (page 220).

Using tongs, dredge the chicken in the egg yolk mixture. Put the chicken in the panko mixture and press the panko onto the chicken. Transfer the chicken to the sheet pan.

CONTINUED

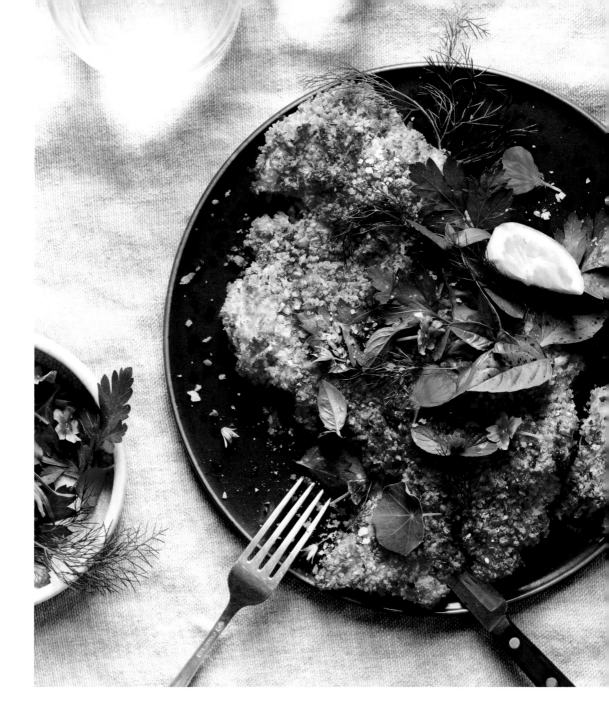

Dukkah-Crusted Crispy Chicken Cutlet with an Herb Salad

CONTINUED

Bake the chicken for 15 to 17 minutes, until the internal temperature of the chicken reaches 165°F. Remove from the oven and let rest.

In a small bowl, toss together **2 cups of coarsely chopped fresh soft herbs,** such as chives and parsley, **a squeeze of ½ lemon**, **a drizzle of olive oil**, **salt**, and **black pepper**. Top each cutlet with a handful of the dressed herbs and serve immediately.

TIPS If you don't want to make the dukkah, you can skip it. Just make sure to add some salt and pepper to the finished cutlet. Arugula works in place of the herb salad.

Riffs on Chicken Thighs

Chicken thighs are my favorite cut of chicken because they stay super tender and flavorful when cooked.

1

Preheat the oven to 400°F. Brown **chicken thighs** in **olive oil** in a cast-iron skillet. Remove the chicken and set aside.

2

Add **an allium** like onion, garlic, leeks, or scallions to the pan and sauté for 30 seconds over medium heat.

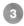

3

Deglaze the pan with **a couple tablespoons of an acid** like wine, vinegar, or lemon juice.

4

Add ½ **cup chicken or vegetable stock**.

5

Add **vegetables** like sliced carrots, sautéed kale, diced potatoes, or trimmed artichokes.

6

Return the chicken thighs to the pan skin-side up and roast, uncovered, for 20 to 25 minutes, or until a meat thermometer registers 165°F.

OPTIONAL
Consider adding **long-grain white rice** and an **additional** **1½ cups stock** and cook for an additional 15 minutes.

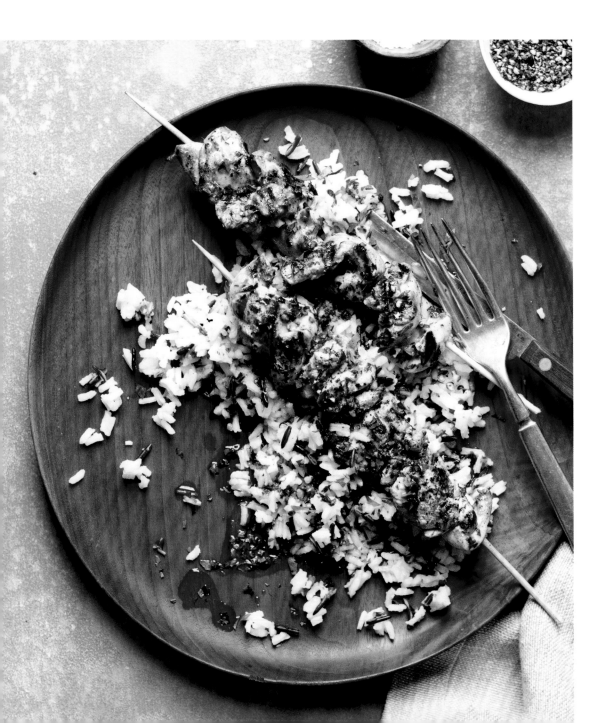

Chicken Skewers with Herbed Balsamic Marinade

Light, Herbaceous, Healthy

SHOPPING LIST

Red pepper flakes

Olive oil

White balsamic vinegar

Dijon mustard

Fresh parsley

Fresh rosemary

Garlic

Shallot

Boneless, skinless chicken thighs

SERVES 4

To make the marinade, combine **¾ cup of olive oil**, **¼ cup of white balsamic vinegar**, **a large pinch of salt**, **1 tablespoon of Dijon mustard**, **a pinch of red pepper flakes**, **1 firmly packed cup of fresh parsley**, **1 tablespoon of chopped fresh rosemary**, **2 cloves of garlic**, and **1 small halved shallot** in a blender or food processor. Blend on high until smooth.

Cut **1½ pounds of boneless, skinless chicken thighs** into 1-inch pieces and put in a large bowl. Pour the marinade over, toss well, cover with plastic wrap, and refrigerate for 1 hour, or up to 12 hours.

Preheat a grill pan over high heat.

Thread the chicken onto four metal skewers. Grill the skewers until the chicken is cooked through, 12 to 14 minutes, turning once, until a meat thermometer reads 165°F. Taste for **salt** and serve warm.

TIPS A meat thermometer will help tell you exactly when the chicken is done. If you have only wooden skewers, make sure to soak them in water for 30 minutes before putting on the grill so they don't burn.

Bacon, Beans, and Greens over Toast

Hearty, Rich, Savory

SERVES 4

Remove the stems from **1 bunch of Swiss chard**; chop the stems into 1-inch pieces and coarsely chop the leaves. Set aside.

In a skillet, cook **4 strips of chopped bacon** over medium heat for 4 to 6 minutes, until crispy. Remove the bacon and drain all but 1 tablespoon of fat from the pan. Add **4 slices of bread** to the pan, and toast over medium-low heat for 2 to 4 minutes, flipping halfway through. Remove and keep warm.

Add more bacon fat if needed, the chard stems, and **a pinch of salt** to the pan and sauté over medium heat for 4 to 6 minutes, until tender. Add **2 minced cloves of garlic**, **1 minced shallot**, and **½ teaspoon smoked paprika** and cook for 30 seconds. Add the chard leaves and another **pinch of salt** and cook until wilted, about 2 minutes. Drain and rinse **1 (15-ounce) can of cannellini beans** and add to the skillet with **1 cup of chicken or vegetable stock** and cook until heated through. Taste for **salt** and **pepper**. Remove the pan from the heat. Top each slice with the bean mixture and bacon and serve warm.

TIP If you want this to be vegetarian, replace the bacon with caramelized onions (page 227) and use vegetable stock.

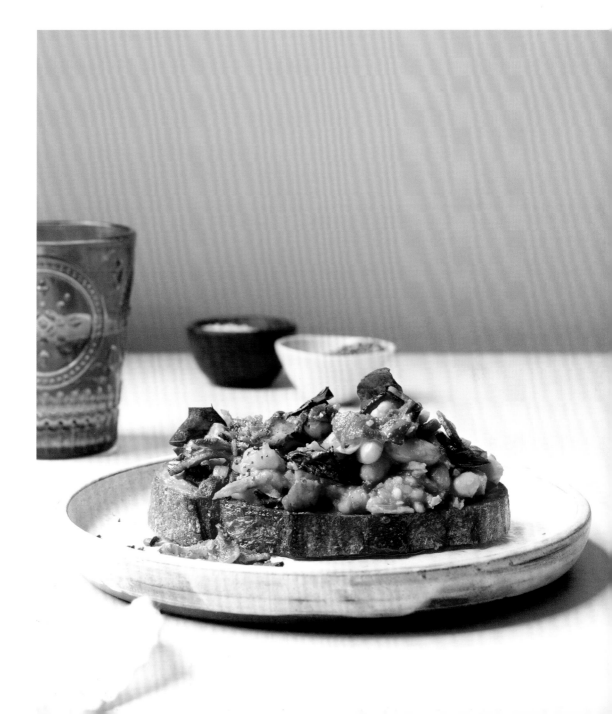

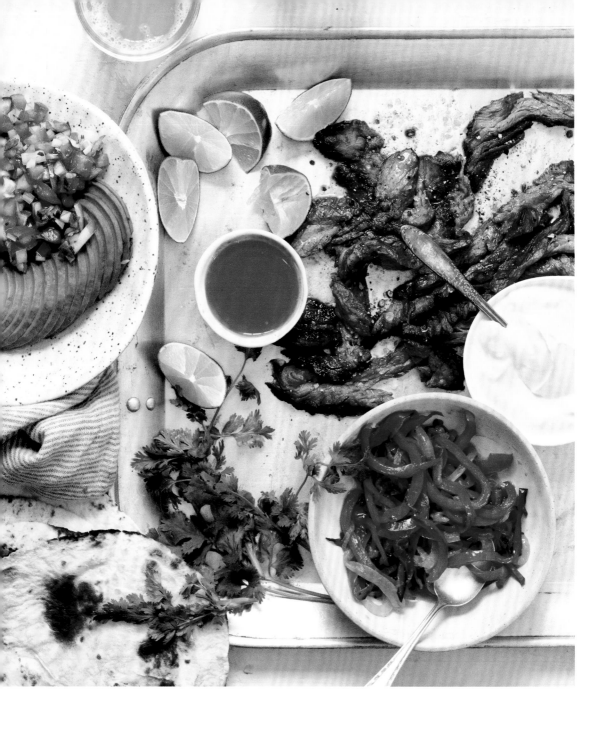

Skirt Steak Fajitas

Filling, Hearty, Satisfying

SERVES 4

SHOPPING LIST

Brown sugar

Cumin

Chili powder

Flour tortillas

Neutral oil

Soy sauce

Fresh salsa

Lime

Garlic

Onion

Red bell pepper

Avocado

Sour cream

Skirt steak

In a medium bowl, combine **¼ cup of soy sauce**, **the juice and finely grated zest of 1 lime**, **¼ cup of neutral oil**, **2 tablespoons of brown sugar**, **2 teaspoons of ground cumin**, **3 minced cloves of garlic**, and **2 teaspoons of chili powder**. Mix well and set aside 2 tablespoons. Add **1 pound of skirt steak**, cut in half if long, cover the bowl, and refrigerate for at least an hour, or up to 12 hours.

Warm **2 tablespoons of neutral oil** in a large cast-iron skillet over medium heat. Add **1 sliced onion**, **1 sliced red bell pepper**, and the reserved marinade and sauté for 4 to 6 minutes, until soft.

In the same cast-iron pan, warm **2 tablespoons of neutral oil**, if needed, over medium heat. Remove the steak from the marinade, place it in the skillet, and cook for 6 to 8 minutes for medium rare, flipping halfway through. Transfer the steak to a clean plate and allow to rest.

Thinly slice the steak against the grain. Serve the fajitas with **warmed flour tortillas**, the onion and red bell pepper mixture, **avocado slices**, **sour cream**, and **fresh salsa**.

TIP Other types of beef, such as flank steak, work well in this recipe—just make sure to adjust the cook time and cook to medium rare.

SUNDAY

SUPPERS

Creamy Risotto with Brussels Sprouts

Nutty, Savory, Creamy

SHOPPING LIST

Arborio rice

Olive oil

Vegetable stock

Onion

Brussels sprouts

Garlic

Fresh chives

Parmesan cheese

Dry white wine

SERVES 4 TO 6

In a large Dutch oven, warm **2 tablespoons of olive oil** over medium heat. Add **1 diced onion, a pinch of salt,** and **a pinch of black pepper** and sauté over medium heat for 4 to 6 minutes, until soft and translucent. Add **1 pound thinly sliced Brussels sprouts** and **2 minced cloves of garlic** and sauté for another 5 minutes, or until the Brussels sprouts have softened and reduced in volume. Add **1½ cups of Arborio rice** and **a large pinch of salt** and stir well, making sure the rice is coated with the oil in the pan. Deglaze with **1 cup of dry white wine** and cook until it is absorbed.

Warm **6 cups of vegetable stock**. Ladle in 1 cup of the stock at a time, stirring continuously and letting the stock be mostly absorbed before adding in the next cup of stock.

Fold in **½ cup of freshly grated Parmesan cheese** and garnish with **chopped fresh chives** and **more Parmesan cheese**.

TIP By very thinly slicing the Brussels sprouts, they basically disintegrate into the risotto as it cooks.

Butternut Squash and Caramelized Onion Galette with Goat Cheese

Comforting, Rich, Tangy

SERVES 4 TO 6

Preheat the oven to 350°F. Line a sheet pan with parchment paper.

Peel, seed, and cut a **1-pound butternut squash** into ½-inch-thick slices. Toss with **2 tablespoons of olive oil** and arrange in a single layer on the prepared sheet pan. Roast for 15 to 20 minutes, until the squash is just barely fork tender but not soft. Remove and set aside.

In a small bowl, combine **4 ounces of soft goat cheese**, **1 tablespoon of fresh chopped thyme leaves, a large pinch of salt**, and **a pinch of black pepper.** Set aside.

Warm **3 tablespoons of olive oil** in a large skillet over medium heat. Add **2 thinly sliced onions** and **a large pinch of salt** and cook over medium-low heat for 45 to 55 minutes, stirring occasionally, until the onions are caramelized. Remove and let the onions cool.

Roll the **pie dough** (page 211) out into a circle about 12 inches in diameter. Spread the herbed goat cheese in the center of the dough, leaving a 2-inch border. Top with the caramelized onions followed by the butternut squash.

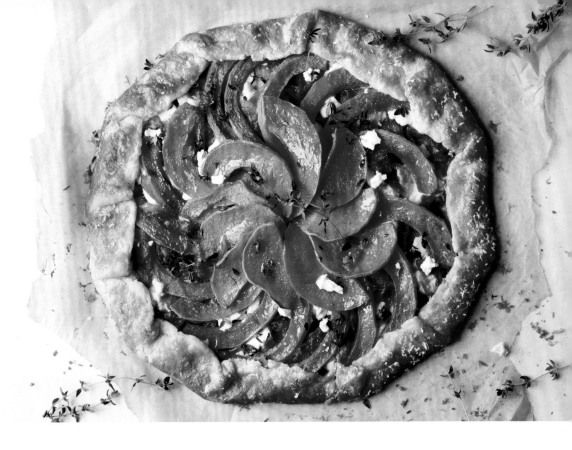

Fold the dough over the filling and brush the edges of the pie dough with **1 egg mixed with 1 tablespoon of water** and sprinkle with **2 tablespoons of Parmesan cheese**.

Bake the galette for about 45 minutes, or until the crust is golden brown and the butternut squash is fork tender.

Garnish with **herbs** and **more soft goat cheese**. Serve warm.

TIPS The pie dough has sugar in it but it is barely noticeable. If you would prefer to make it more savory, just omit the sugar from the recipe on page 211. The caramelized onions take the longest in this recipe; you can make them ahead of time and store in the fridge for up to 3 days.

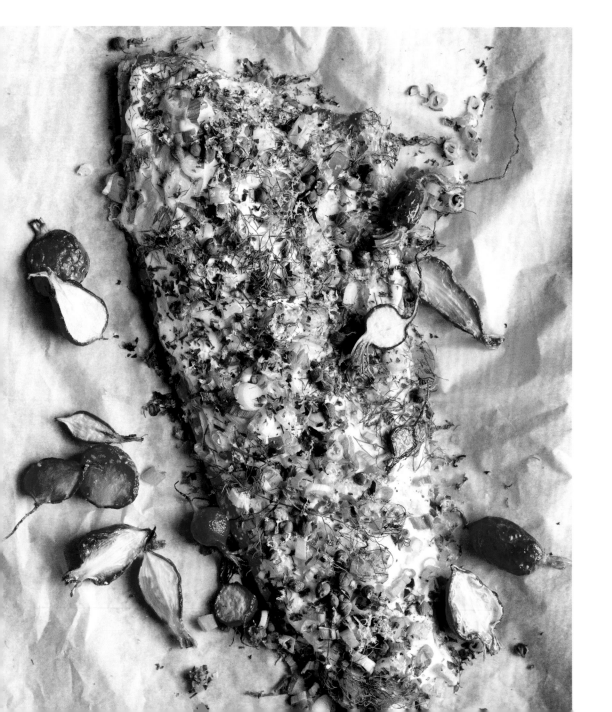

Roasted Arctic Char with Herbs and Roasted Radishes

Fresh, Herbaceous, Light

SHOPPING LIST

Red pepper flakes

Olive oil

Mayonnaise

Capers

Radishes

Scallions

Lemon

Fresh soft herbs

Arctic char

SERVES 6

Preheat the oven to 425°F. Line a sheet pan with parchment paper.

Trim and halve **2 bunches of radishes** and toss with **2 tablespoons of olive oil**, **salt**, and **black pepper**. Spread out in an even layer on the prepared sheet pan. Roast for 20 to 22 minutes, until fork tender.

Place **2 pounds of skin-on arctic char** in a shallow baking dish, skin-side down. Brush with **2 tablespoons of mayonnaise** and sprinkle with **salt** and **black pepper**.

In a small bowl, combine **1 bunch of chopped scallions, 2 tablespoons of capers**, **finely grated zest of 1 lemon**, **a pinch of red pepper flakes**, and **1 cup of chopped soft herbs**, such as dill, parsley, and basil. Sprinkle over the fish.

Roast alongside the radishes for 9 to 11 minutes, until a knife can be inserted easily without any resistance. Let rest for 5 minutes, then serve warm.

TIP If you can't find arctic char, use salmon instead.

Seared Scallops with Green Peas, Mint, and Shallots

Salty, Sweet, Light

SERVES ABOUT 4

In a large pot of salted boiling water, blanch **2½ cups of fresh or frozen green peas** until bright green and soft, 3 to 5 minutes. Reserve ½ cup of the peas and put the rest in a blender. Blend, drizzling in **¼ to ½ cup of water** to reach a creamy consistency. Add **¼ cup of fresh mint leaves, a large pinch of salt**, and **a pinch of black pepper** and blend until smooth. Set aside but keep warm.

In a large cast-iron skillet, cook **4 strips of bacon** chopped into ½-inch pieces over medium heat until the fat is rendered, 4 to 6 minutes. Remove and pour out all but 1 tablespoon of fat, reserving the remaining fat and setting aside. Add **1 large minced shallot** and sauté for 30 seconds. Add the reserved peas and bacon. Cook for 30 seconds, then remove but keep warm.

In the same pan, warm 2 tablespoons of the reserved fat over high heat until just barely smoking, then add **1½ pounds of well-dried large sea scallops with the foot muscle removed**, and cook for 2 minutes on each side.

Serve with the pea puree, a sprinkle of the bacon mixture, and flaky sea salt if needed.

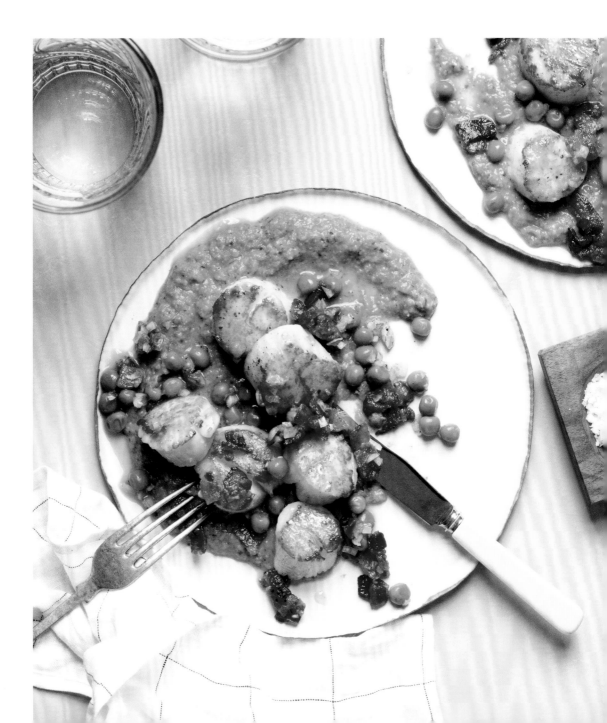

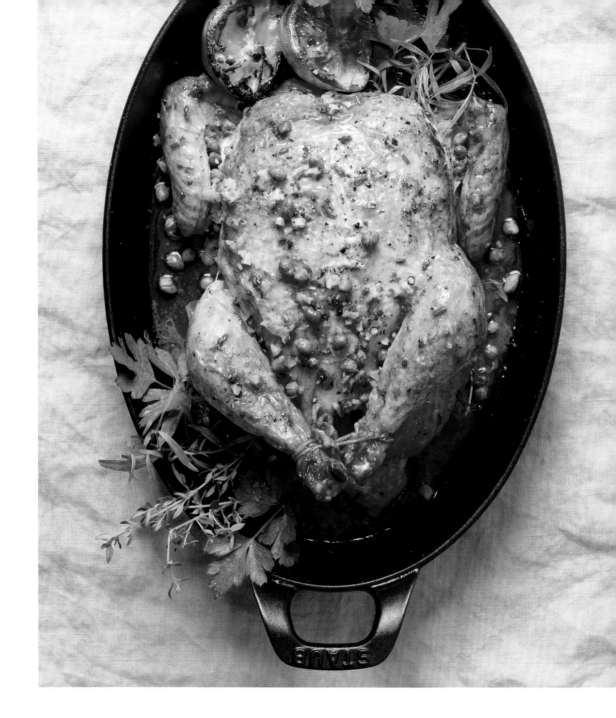

Roast Chicken with Fried Capers and Lemon

Lemony, Savory, Comforting

SERVES 4

Preheat the oven to 450°F.

Melt **2 tablespoons of butter** over medium-high heat in a large cast-iron skillet. Carefully pour the butter into a bowl. Place **a whole chicken** breast-side up in the same pan and brush with the melted butter and sprinkle with a **large pinch of salt** and **a pinch of black pepper**.

Roast the chicken for 45 to 50 minutes, until a meat thermometer reaches 165°F when inserted in between the leg and the breast of the chicken, tenting the chicken with foil if it becomes too browned. Carefully remove from the pan and let rest.

In the same pan with the pan drippings, add **2 tablespoons of capers** and **2 minced cloves of garlic** and fry over medium heat for about 1 minute. Add the **finely grated zest and juice of 1 lemon** and bring to a boil. Reduce slightly, then pour over the chicken.

Serve immediately.

TIP Make sure to dry the chicken really well before basting with butter, so the skin gets extra crispy.

Vegetable Wontons in a Coconut Thai Curry Broth

Fragrant, Hearty, Complex

SERVES 4 TO 6

In a wok or skillet, warm **1 tablespoon of toasted sesame oil** over medium heat. Add **1 minced shallot, 2 minced cloves of garlic, 1 tablespoon of grated fresh ginger**, and a **1-inch piece of chopped lemongrass** and sauté for 30 seconds. Add **8 ounces of thinly sliced shiitakes** and sauté for 4 to 6 minutes, until the mushrooms are soft. Chop and add **2 heads of bok choy** and sauté until the bok choy is wilted, 2 to 4 minutes. Remove from the heat and let cool. Coarsely chop the mixture.

Place 1 teaspoon of filling in one of the corners of **40 store-bought wonton wrappers**, leaving a small border. Brush the edges of the wonton wrapper with water, fold one side of the wonton wrapper over the filling, and press the edges to seal. Repeat with the remaining filling and wonton wrappers.

CONTINUED

Vegetable Wontons in a Coconut Thai Curry Broth

CONTINUED

In a Dutch oven, warm **1 tablespoon of toasted sesame oil** over medium heat. Mince a **1-inch piece of lemongrass** and add with **2 minced cloves of garlic** and **1 minced shallot** and sauté for 30 seconds. Add **1 tablespoon of red curry paste** and sauté for another 30 seconds. Add **1 (15-ounce) can of coconut milk**, **1¼ cups of vegetable stock,** and **2 tablespoons of fish sauce** and mix well. Chop and add **1 head of bok choy** and sauté until barely wilted, 1 to 2 minutes.

Bring a large pot of salted water to a boil and add the wontons. Cook the wontons for 2 to 3 minutes, until they float to the top. Transfer to the broth.

Serve the dish topped with coarsely chopped **fresh basil** and **lime wedges**.

TIPS The recipe for the wontons makes a lot of wontons. Only use about half for this soup and freeze the rest to save time the next time you want to make this dish; cook from frozen, adding a couple more minutes to the cook time. Fresh lemongrass can be found in the produce section of most grocery stores. If you can't find it, just skip it.

Lasagna with Chicken Sausage and Spinach

Hearty, Flavorful, Comforting

SHOPPING LIST

No-boil lasagna noodles

Olive oil

Canned diced tomatoes

Onion

Garlic

Fresh spinach

Lemon

Fresh thyme

Egg

Ricotta cheese

Parmesan cheese

Mozzarella cheese

Bulk raw chicken sausage

SERVES 6 TO 8

In a large skillet, warm **2 tablespoons of olive oil** over medium heat. Add **1 thinly sliced onion** and sauté for 4 to 6 minutes, until the onion is soft and translucent. Add **2 minced cloves of garlic** and sauté for another 30 seconds. Add **2 (28-ounce) cans of diced tomatoes** and cook over medium heat for 25 to 30 minutes, until reduced by half. Set aside.

In a large skillet over medium heat, warm **2 tablespoons of olive oil**. Add **1 pound of fresh spinach** and sauté until wilted, 2 to 4 minutes, working in batches, if needed. Transfer the spinach to a bowl lined with cheesecloth or a paper towel and squeeze to remove excess liquid. Set aside.

In the same pan, warm **2 tablespoons of olive oil** over medium heat. Add **1 pound of bulk raw chicken sausage** and sauté until golden brown, about 5 minutes, breaking up any large pieces into small crumbles. Add to the bowl with the spinach.

CONTINUED

Lasagna with Chicken Sausage and Spinach

CONTINUED

Combine **30 ounces of ricotta**, the **finely grated zest of 1 lemon**, **1 egg**, **1 tablespoon of chopped fresh thyme**, **a big pinch of salt**, and **a pinch of black pepper** in a bowl and mix well. Set aside.

Combine **1 cup of freshly grated Parmesan cheese** and **3 cups of shredded mozzarella** in a bowl and toss to mix well.

Preheat the oven to 375°F.

To assemble, in a 9 by 13-inch baking pan, pour in 1 cup of the tomato mixture and top with **4 no-boil lasagna noodles**. Top the noodles with 1 cup of the ricotta mixture followed by 1 cup of the tomato mixture, 1 cup of the spinach and sausage mixture, and 1 cup of the Parmesan and mozzarella mixture. Top with **4 no-boil lasagna noodles** and follow the same pattern two more times. Top with the remaining **4 no-boil lasagna noodles**, remaining tomato mixture, and remaining shredded cheese.

Cover the lasagna with aluminum foil and bake for 40 minutes. Remove the foil and bake for another 20 minutes. Let sit for 15 minutes before serving.

TIP This recipe is a time investment, but well worth it. It is perfect for a Sunday night dinner or dinner party. It also freezes well.

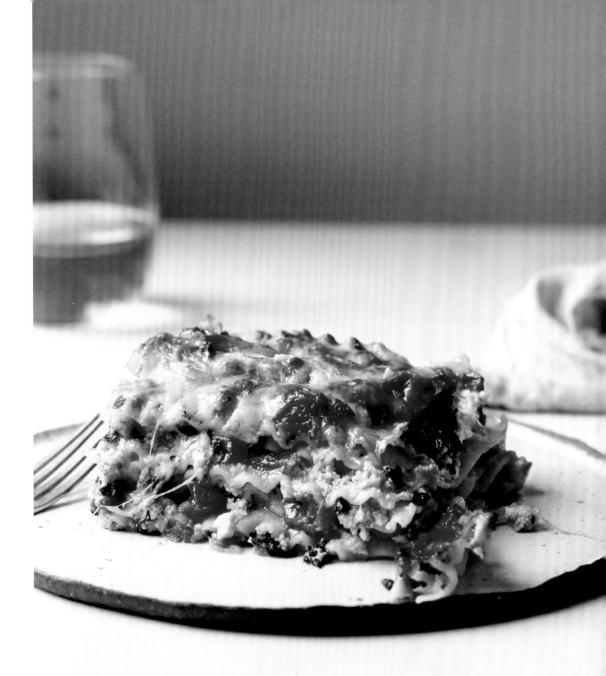

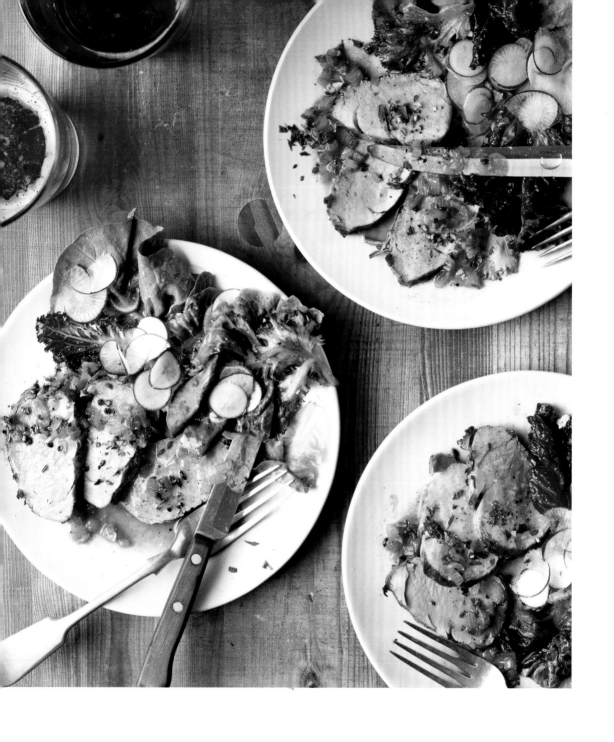

Mustardy Pork Tenderloin

Satisfying, Anise, Bright

SHOPPING LIST

Caraway seeds
Maple syrup
Olive oil
Dijon mustard
Apple cider
vinegar
Chicken stock
Shallot
Butter
Pork tenderloin

SERVES 4 TO 6

In a large bowl, combine **2 tablespoons of Dijon mustard,
3 tablespoons of maple syrup, 1 tablespoon of whole caraway
seeds, 2 tablespoons of apple cider vinegar, 2 tablespoons
of olive oil, 2 teaspoons of salt,** and **1 teaspoon of pepper.** Add
1 pork tenderloin (about 1½ pounds) and let marinate for at least
1 hour, or up to 12 hours in the refrigerator.

Preheat the oven to 400°F.

Warm **2 tablespoons of olive oil** over medium-high heat in a large
cast-iron skillet. Sear the pork until brown on all sides, then roast in
the oven for 12 to 14 minutes, until 135°F on a meat thermometer.

Let the pork rest on a large plate for 10 minutes, covered with
aluminum foil. Add **1 minced shallot** to the skillet and sauté over
medium heat for 30 seconds, then deglaze the pan with
2 tablespoons of apple cider vinegar and **¼ cup of chicken stock.**
Cook the mixture for 1 to 2 minutes, or until reduced by half.
Add **2 tablespoons of butter** and continue cooking until melted.

Slice the tenderloin, drizzle with pan sauces, and serve warm.

TIP Use a meat thermometer to make sure you don't overcook the pork,
which will cause it to dry out and lose flavor.

Espresso and Brown Sugar–Braised Pork Shoulder with Fresh Corn Polenta

Comforting, Hearty, Satisfying

SERVES 4 TO 6

Mix together **1 tablespoon of salt, 2 teaspoons of ground black pepper**, **1 teaspoon of chili powder**, and **½ teaspoon of ground cinnamon** in a small bowl. Sprinkle the mixture over a **2½-pound boneless pork shoulder** and allow to marinate in the fridge for at least 1 hour, up to overnight.

Preheat the oven to 350°F.

Warm **2 tablespoons of olive oil** in a large Dutch oven over medium-high heat. Brown the pork on all sides. Remove and set aside. Carefully pour off all but 1 tablespoon of fat. Add **1 large thinly sliced onion** and sauté until soft, 4 to 6 minutes. Add **3 minced cloves of garlic, 2 tablespoons of brown sugar, 1 teaspoon of chili powder**, and **a large pinch of salt** and cook for another 30 seconds. Deglaze the pan with a **12-ounce bottle of dark beer**, such as a porter. Add **1 tablespoon of instant espresso powder** mixed with **2 tablespoons of water**. Add **4 cups of chicken stock** and stir well. Return the pork to the pot, cover, and cook in the oven for 2½ to 3 hours, until the meat falls apart easily. Remove from the braising liquid and shred with two forks.

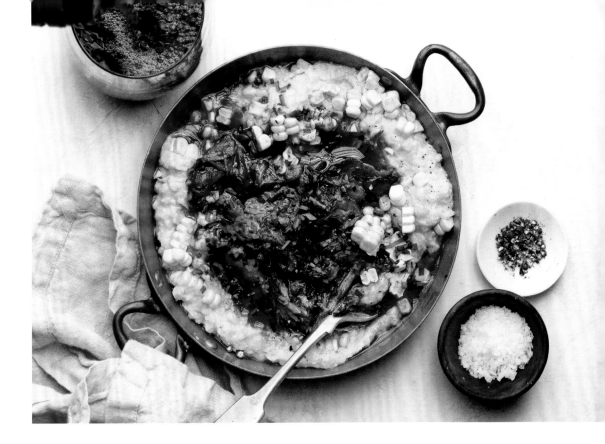

While the pork is braising, add the kernels from **8 ears of fresh sweet corn** to a large pot of salted boiling water and cook until soft, 6 to 8 minutes. Drain.

Put all but 1 cup of the kernels in a food processor. Add **2 tablespoons of butter** and pulse until creamy. Taste for **salt** and **pepper**. Fold in the reserved whole kernels.

To serve, add a large spoonful of corn and pork to each plate.

TIP Reduce the braising liquid to create a sauce to top the pork and polenta.

Oven-Roasted Spareribs with Gochujang BBQ Sauce

Spicy, Rich, Vinegary

SERVES 4 TO 6

Preheat the oven to 350°F. Set wire racks on two sheet pans.

To make the seasoning, in a small bowl, combine **¼ cup of firmly packed brown sugar**, **2 tablespoons of chili powder**, **2 tablespoons of salt**, **2 teaspoons of black pepper**, **2 teaspoons of onion powder**, **2 teaspoons of garlic powder**, and **2 teaspoons of liquid smoke**. Stir well.

Individually, place **2 racks of spareribs**, **about 2½ pounds each**, with the membranes removed, in the middle of large pieces of aluminum foil. Rub the seasoning over the ribs. Wrap the ribs tightly with the foil and place on the prepared sheet pans. Roast the ribs for 2½ to 3 hours, until the meat is tender and a knife can be inserted easily between the bones. Remove from the oven and remove the ribs from the foil.

To make the barbecue sauce, carefully pour any excess liquid from the ribs into a medium saucepan. Add **¾ cup of apple cider vinegar**, **1 teaspoon of liquid smoke, 2 teaspoons or more of gochujang**, and **½ cup of firmly packed brown sugar**. Whisk well and bring to a boil. Lower the heat and cook for 3 to 5 minutes,

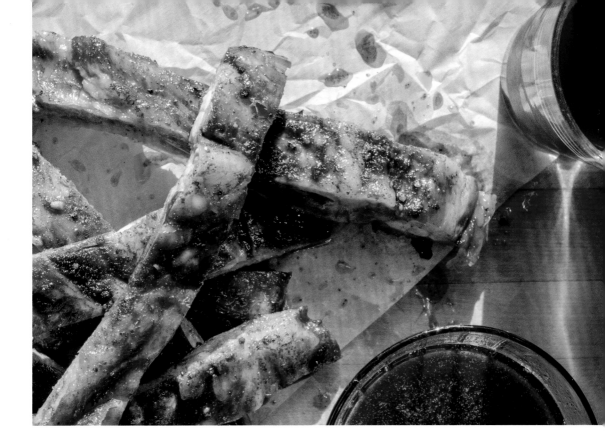

until slightly reduced. Place the ribs back on the prepared sheet pans and brush with the barbecue sauce. Increase the oven to broil and broil the ribs for 5 minutes, or until just barely charred.

Cut the racks into single ribs. Serve with leftover barbecue sauce for dipping.

TIP Gochujang is a fermented Korean chile paste that is sweet and spicy. It can be found at many grocery stores and is worth seeking out. I like to put it on anything that needs a little bit of spiciness that is mellowed with a little sweetness. If you can't find it, just skip it; the rub has enough heat in it to give this dish a little kick.

SHOPPING LIST
Pink peppercorns
Olive oil
Neutral oil
Fresh thyme
New potatoes
Butter
New York strip
steak

NY Strip Steak with Smashed Potatoes and Pink Peppercorn Compound Butter

Hearty, Filling, Rich

SERVES 4 TO 6 SERVINGS

Preheat the oven to 450°F.

In a bowl, mash together **½ cup of room-temperature butter**, **2 tablespoons of chopped fresh thyme leaves**, and **1 teaspoon of coarsely chopped pink peppercorns**. Set aside.

In a large pot of boiling water, boil **1 pound of new potatoes** until tender, 10 to 12 minutes. Drain, place on a sheet pan, smash each potato with a fork, and top with a **drizzle of olive oil, a pinch of salt, a pinch of black pepper,** and **a sprinkle of chopped fresh thyme leaves**. Roast for 18 to 20 minutes, or until crispy.

Heat **1 tablespoon of neutral oil** in a cast-iron skillet over high heat. Add **½ teaspoon of salt** followed by **1 boneless New York strip steak about 1 inch thick**. Sear for 3 minutes, flip, then place in the oven with the potatoes for 3 minutes for medium rare. Remove from the oven, place on a plate, and cover with aluminum foil to rest. Serve alongside the potatoes with dollops of compound butter.

TIPS Let the steak sit at room temperature for 30 minutes before cooking. Dry well with a paper towel. If you can't find pink peppercorns, use black.

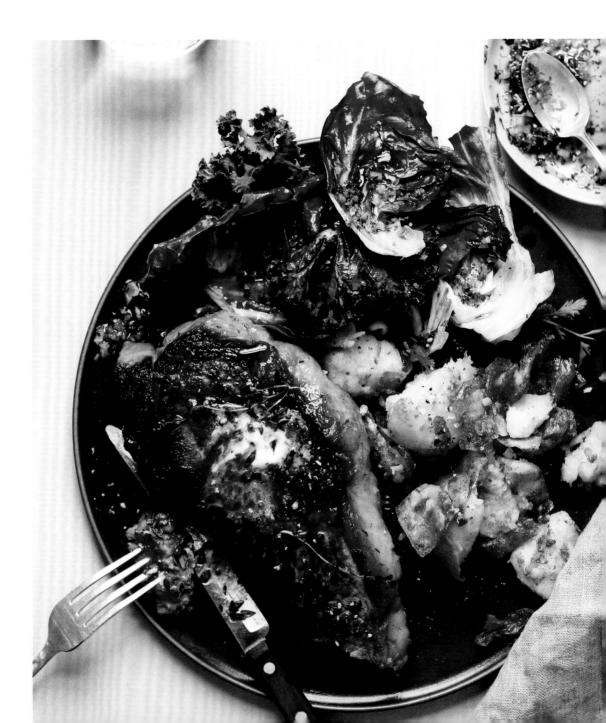

SOMETHING

SWEET

Orange Bread Crumb Cake

Sweet, Fragrant, Citrusy

SERVES 6 TO 8

Preheat the oven to 350°F. Butter a 9-inch springform pan.

In a medium bowl, combine **½ cup of sugar**, **1 cup of almond flour**, **½ cup of dried bread crumbs**, **the finely grated zest of 2 oranges**, **the finely grated zest of 1 lemon**, and **1½ teaspoons of baking powder.** Save the citrus for juicing later.

Separate **4 eggs**. In a large bowl, combine the egg yolks and **¾ cup of neutral oil**. Add in the dry ingredients and mix well; the mixture will be very thick.

In the bowl of a stand mixer fitted with a whisk attachment, beat the egg whites on low speed until small bubbles appear. Increase the speed to high and beat until soft peaks form. Slowly add **2 tablespoons of sugar** and continue beating on high until the egg whites form stiff glossy peaks.

Gently fold the egg whites into the egg yolk mixture.

CONTINUED

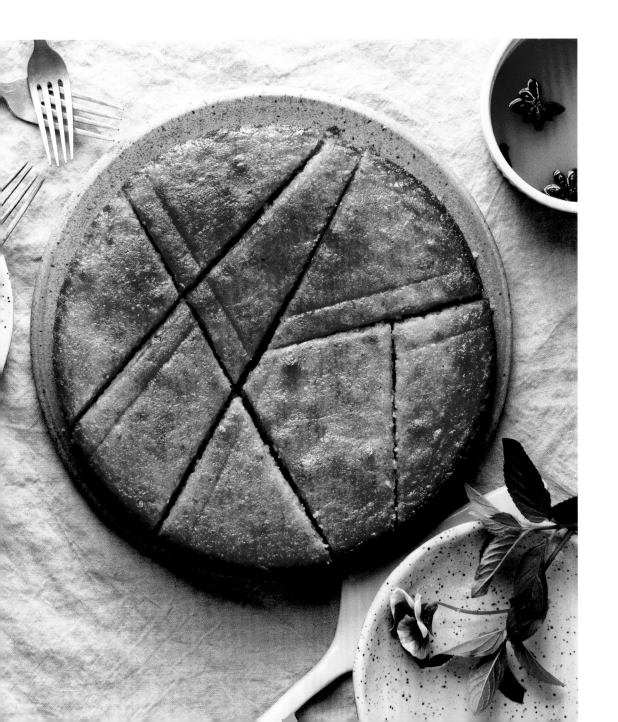

Orange Bread
Crumb Cake

CONTINUED

Pour the batter into the prepared cake pan and bake for 40 minutes, or until a toothpick comes out clean. Allow the cake to cool slightly in the pan.

While the cake is baking, make the syrup by combining the **juice of 2 oranges** and **1 lemon** in a small pan, followed by **¼ cup of sugar**, **2 whole cloves**, and **2 whole star anise**. Stir over low heat until the sugar dissolves and the liquid reduces by half.

Using a pastry brush, brush the top of the warm cake with all of the orange syrup, allowing it to soak in.

If desired, serve the cake with a dollop of **crème fraîche** or **Greek yogurt**.

TIP The star anise is a dominant flavor in this cake. If you don't like anise flavor, simply leave it out.

Riffs on Pie Dough

See page 211 for my favorite pie dough recipe.

→ **MAKE A GALETTE** Roll out **the pie dough** to 12 inches in diameter. Toss **fruit** like peaches or strawberries with **sugar**, **a pinch of salt**, and **a couple of tablespoons of cornstarch**. Place the fruit in the middle of the pie dough, leaving a 3-inch border. Pleat the pie dough over the fruit, brush the edges with **an egg** mixed with **a couple of tablespoons of water**, then bake at 375°F until the filling is bubbling and the pie dough is golden brown, about 45 minutes.

→ **MAKE CHEESE CRACKERS** Roll out **the pie dough** to a large rectangle, about ¼ inch thick. Brush with **an egg** mixed with **a couple of tablespoons of water**, then sprinkle with **freshly grated Parmesan cheese** and **black pepper**. Cut into squares, then bake at 375°F until golden, 15 to 20 minutes.

→ **MAKE HAND PIES** Divide **the pie dough** into four or five smaller pieces, then roll each out to about 7 inches in diameter. Fill one side with either a **fruit filling** or **meat filling**, cover the filling with the other side of the pie dough, and crimp the edges. Bake at 375°F until the pie dough is golden brown, about 30 minutes.

→ **MAKE COOKIES** Roll out **the pie dough** and sprinkle it with **sugar** and **cinnamon**. With your hands, roll half of the pie dough into the center, followed by the other half. Slice the log into ½-inch-thick cookies and bake at 425°F on their flat side until golden, 10 to 12 minutes.

→ **MAKE A QUICHE** Roll out **the pie dough** to 12 inches in diameter and fit in a pie plate. In a bowl, whisk together **3 eggs**, **1 cup of cheese**, **1½ cups of half-and-half**, and **1 cup of cooked bacon pieces**. Pour the filling into the pie dough and bake at 425°F until the filling is set and the crust is golden brown, about 45 minutes.

The Perfect Chocolate Birthday Cake

Rich, Chocolatey, Decadent

SERVES 6 TO 8

Preheat the oven to 325°F. Line a 9 by 13-inch cake pan with parchment paper and spray with nonstick cooking spray.

Melt **4 ounces of bittersweet chocolate**. Set aside and let it cool slightly.

In a bowl, combine **2 cups of flour**, **2 teaspoons of baking soda**, and **¾ teaspoon of salt**. Set aside.

In another bowl, combine **¾ cup of sour cream** and **1 cup of warm water**. Set aside.

In the bowl of a stand mixer fitted with a paddle attachment, cream together **1⅓ cups of firmly packed light brown sugar** and **½ cup of room-temperature butter** until light and fluffy, 3 to 4 minutes. With the mixer on low, add **3 eggs**, one at a time; **1 tablespoon of vanilla extract**; and **1 teaspoon of instant espresso mixed with 1 tablespoon of water**. Mix well. Add the melted chocolate and mix until completely combined.

Alternate adding in the flour and the sour cream mixture, starting and ending with the flour mixture.

Transfer the batter to the prepared cake pan. Bake for 40 to 45 minutes, or until a toothpick comes out clean. Let the cake cool slightly in the pan, then remove it from the pan and let it cool completely on a rack.

When you are ready to eat, frost it with **milk chocolate frosting** (page 196).

TIP The unfrosted cake will last for 3 days wrapped in plastic wrap in the fridge or 2 weeks in the freezer.

Milk Chocolate Frosting

Sweet, Smooth, Chocolatey

MAKES ENOUGH FROSTING FOR A 9 BY 13-INCH SHEET CAKE

Heat **⅔ cup of whole milk** in a small pan over medium heat until hot.

Melt **8 ounces of milk chocolate** and **2 ounces of bittersweet chocolate**. Set aside and let cool slightly.

In a bowl, whisk together **3 egg yolks**, **1 tablespoon of flour**, **⅓ cup of confectioners' sugar**, and **a pinch of salt**. Whisking constantly, add the hot milk in a slow, steady stream. Transfer to a saucepan and bring to a boil over medium heat, whisking. Reduce the heat and simmer, whisking, for about 2 minutes, until it becomes very thick. Transfer to the bowl of a stand mixer, cover the surface with plastic wrap, and let cool completely, about 45 minutes.

Add **1 tablespoon of vanilla** and **1 cup of confectioners' sugar** to the cooled mixture. With a stand mixer fitted with a paddle attachment, beat on medium speed until well combined, 1 to 2 minutes. Increase the speed to medium-high and beat in **1 cup of room-temperature butter**, 2 tablespoons at a time, until smooth. Add the cooled melted chocolates and beat until combined well.

TIP Store frosting in the fridge for up to 3 days. Before using, let come to room temperature before beating on high to fluff before spreading on the cake.

White Chocolate Ice Cream with Roasted Strawberry

Sweet, Creamy, Luscious

MAKES ABOUT 1 QUART

In a pot, heat **2 cups of heavy cream** and **1 cup of whole milk**. Using the tip of a paring knife, slice **a vanilla bean** in half lengthwise and scrape out the seeds. Add both the pod and the seeds to the cream mixture and set over medium-low heat until barely simmering. Remove from heat, cover with plastic wrap, and set aside for 20 minutes, but keep warm. Remove and discard the pod.

In a bowl, whisk together **5 egg yolks**, **¼ cup of sugar**, and **1 pinch of salt**. Add 1 cup of the warm cream mixture, whisking constantly. Add the rest of the cream mixture and mix well. Return the mixture to the pan and cook over medium-low heat for 3 to 4 minutes, or until the mixture thickens slightly and coats the back of a spoon.

Strain into large bowl and stir in **1½ cups of white chocolate chips**. Let the chocolate melt in the cream for about 5 minutes, then whisk until smooth. Pour into a zippered plastic bag and freeze in an even layer.

CONTINUED

White Chocolate Ice Cream
with Roasted Strawberry

CONTINUED

To prepare the strawberries, preheat the oven to 425°F.

Hull and slice **1 pint of strawberries** and toss with **2 tablespoons of sugar** and **a pinch of salt**. Lay the strawberries in a medium ovenproof baking pan and roast until soft, 15 to 20 minutes. Let cool.

Break the frozen ice cream base into small pieces, put into a food processor, and pulse until smooth. Pulse in strawberries until barely combined. Return the base to the freezer and freeze for at least 2 hours or store in an airtight container for up to 3 weeks.

TIP If you have an ice-cream machine, feel free to use it, but a food processor works well in its place.

Millionaire's Tart

Salty, Sweet, Rich

SHOPPING LIST
Sugar
Brown sugar
Flour
Bittersweet chocolate
Sweetened condensed milk
Corn syrup
Vanilla extract
Butter
Heavy cream
Egg

SERVES 6 TO 8

Preheat the oven to 400°F.

In the bowl of a food processor, pulse to combine **1¼ cups of flour, ⅓ cup of sugar**, and **a pinch of salt**. Add **½ cup of butter** cut into small pieces and pulse to combine until the butter is the size of peas. Add **1 egg yolk** and pulse until the dough stays together.

Press the dough into a 9-inch tart pan with a removable bottom. Using your hands, press the dough into the bottom and up the sides of the pan. Bake for 18 to 22 minutes, until the crust is golden brown. Let the tart shell cool.

In a saucepan, combine **½ cup of firmly packed brown sugar, 1 (14-ounce) can of sweetened condensed milk, 2 tablespoons of corn syrup, ¼ cup of heavy cream, 4 tablespoons of butter**, and **¾ teaspoon of salt**. Cook, stirring often, until the butter melts and the mixture is smooth, about 3 minutes. Bring to a boil and cook, stirring constantly, until the mixture reaches 235°F on a thermometer and is golden brown, 10 to 12 minutes. Remove

CONTINUED

Millionaire's Tart

CONTINUED

from the heat and stir in **2 teaspoons of vanilla extract**. Carefully pour this caramel evenly over the tart shell and cool at room temperature until completely set, about 2 hours, or overnight.

Finely chop **4 ounces of bittersweet chocolate**. Melt half of the chocolate in a double boiler. Remove the pan from the heat, fold in the remaining chocolate, and stir until melted. Pour the chocolate over the tart. Let sit for 30 minutes, then sprinkle with **a large pinch of flaky sea salt**. Let the chocolate cool at room temperature and harden completely before serving.

TIP This recipe calls for corn syrup, which will help the caramel layer stay smooth and chewy and prevent any sort of sugar crystallization while it cooks. I know people have strong feelings about corn syrup, so you can swap the corn syrup for brown rice syrup or golden syrup.

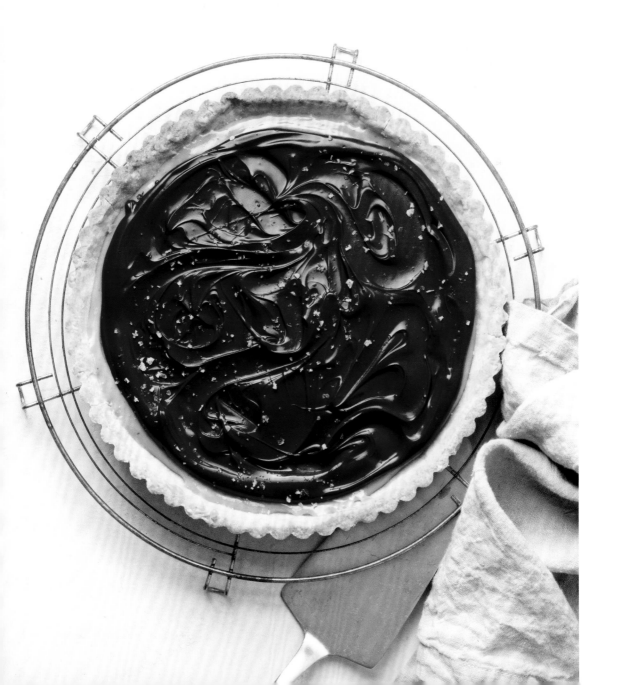

SHOPPING LIST
Cream of tartar
Sugar
Graham crackers
Vanilla extract
Key lime juice
Lime
Eggs
Butter
Whipping cream

Pavlova with Key Lime Curd and Graham Cracker Crumbs

Sweet, Crunchy, Citrusy

`

SERVES 6

Preheat the oven to 200°F. Line a sheet pan with parchment paper.

In the bowl of a stand mixer fitted with a whisk attachment, beat **6 room-temperature egg whites** and **a pinch of cream of tartar** on medium speed until small bubbles form. Increase the speed to high and beat until soft peaks form. Add **1½ cups of sugar**, 1 tablespoon at a time, and beat until glossy stiff peaks form. Fold in **1 teaspoon of vanilla**. Scoop the meringue onto the parchment paper in a circular mound. Bake for about 1 hour, until dry to the touch. Turn off the oven and let the meringue cool with the oven.

Bring 3 inches of water to a boil in a pot over medium-high heat. In a heatproof bowl, combine **3 large eggs**, **2 egg yolks**, **1 cup of sugar**, **⅔ cup of fresh or store-bought key lime juice**, and the **finely grated zest of 1 lime**. Set the bowl on top of the simmering water and whisk until the mixture is thick and coats the back of a spoon, about 10 minutes. Remove from the heat and fold in **4 tablespoons of butter** cut into small pieces. Transfer to a clean bowl and cover with plastic wrap, pressing onto the curd. Let cool, then refrigerate.

Top with key lime curd, **1 cup of whipped cream**, and **¼ cup of crushed graham crackers**. Slice and serve immediately.

Cracked Cookie Bark

Nostalgic, Comforting, Addicting

SHOPPING LIST

Flour

Baking soda

Brown sugar

Sugar

Semisweet
chocolate chips

Vanilla Extract

Egg

Butter

MAKES 1 COOKIE, ABOUT 9 BY 13-INCHES

Preheat the oven to 325°F. Line a sheet pan with parchment paper.

In a bowl, whisk together **1¼ cups of flour**, **½ teaspoon of baking soda**, and **1 teaspoon of salt**. Set aside.

In the bowl of a stand mixer fitted with a paddle attachment, beat together **1 cup of room-temperature butter**, **½ cup of firmly packed brown sugar**, and **½ cup of granulated sugar** until light and fluffy, 2 to 4 minutes. Add **2 teaspoons of vanilla extract** and **1 egg**. Mix on medium speed until well incorporated, about 30 seconds.

Add the flour mixture to the bowl and mix on medium speed until barely combined, 15 to 30 seconds. Fold in **6 ounces of semisweet chocolate chips**.

Spread the batter on the prepared sheet pan into an even layer. Bake for 10 minutes, then carefully remove and bang the pan on the floor or a heat-safe countertop. Return to the oven and bake for another 5 to 7 minutes, until the cookie is golden brown.

Remove and sprinkle with **flaky sea salt**. Let the cookie cool for at least 30 minutes, then use your hands to break it into pieces.

TIPS The batter may be sticky; it doesn't have to be perfect, but do your best to create an even layer. You can also shape these into regular cookies.

SHOPPING LIST

Sugar

Powdered gelatin

Fresh basil

Berries

Lemon

Half-and-half

Basil Panna Cotta with Macerated Berries

Floral, Light, Summery

SERVES 6

In a saucepan, bring **3 cups of half-and-half**, **⅓ cup of sugar**, **a pinch of salt**, and **1 cup of fresh basil leaves** to a simmer. Remove from the heat, cover with plastic wrap, and let sit for 20 minutes.

Sprinkle **2 (¼-ounce) packages of plain powdered gelatin** over **3 tablespoons of cold water** in a small bowl and let sit for 5 minutes, or until the gelatin blooms and absorbs all of the water.

Add the gelatin mixture to the warm half-and-half mixture and whisk to combine. Gently reheat the half-and-half mixture if the gelatin does not dissolve easily. Strain and divide the mixture among six 4-ounce ramekins. Refrigerate for at least 4 hours, up to 24 hours.

Combine **2 cups of berries**, such as raspberries and blackberries, in a large bowl with **2 tablespoons of sugar** and **1 teaspoon of finely grated lemon zest**. Let sit for 20 minutes.

Dip the bottom of each ramekin into a bowl of hot water, then run a knife around the edge and invert onto individual serving plates. Top with the macerated berries and serve immediately.

TIP Fresh mint works in place of basil.

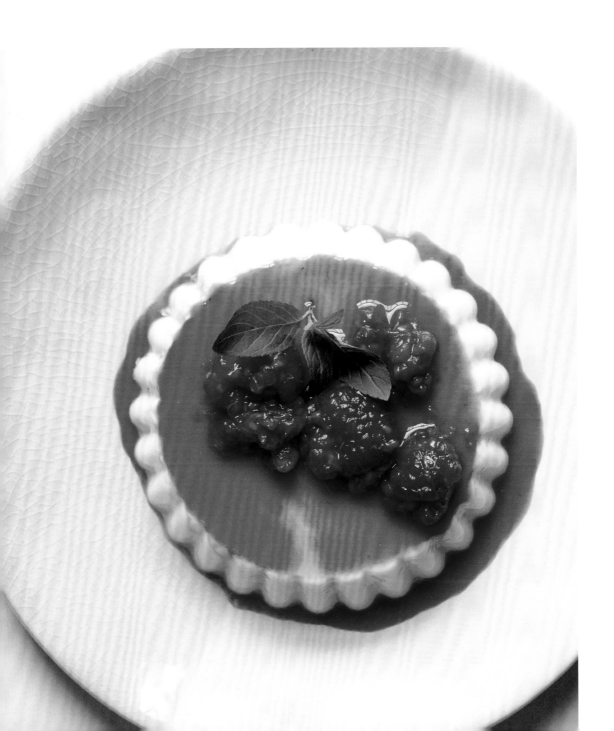

The Perfect Pie Dough

Flaky, Buttery, Rich

SHOPPING LIST
Flour
Sugar
Butter
Buttermilk
(optional)

MAKES PASTRY FOR A SINGLE CRUST

In the bowl of a stand mixer fitted with a paddle attachment or food processor, combine **1¼ cups of flour, 1 tablespoon of sugar**, and **a pinch of salt**. Pulse or mix for a few seconds. Add **½ cup of butter** cut into pieces and pulse for about 10 seconds, until the butter is incorporated into the flour and is the size of peas. Add **3 tablespoons of water or buttermilk** and pulse or mix, until the dough just comes together. If the dough is dry, add **1 tablespoon more of water**. Gather the dough into a ball, wrap in plastic wrap, and refrigerate for at least an hour or up to 3 days (or throw it in the freezer and freeze for up to a month and defrost in the fridge overnight before using).

TIPS The key to flaky pie dough is to always keep the dough cold and to not overwork the dough, which will make it chewy rather than flaky. I call for water or buttermilk here; feel free to use either. Double the recipe to make a top and bottom crust.

Peach, Oatmeal, and Thyme Pie

Summery, Nostalgic, Aromatic

SERVES 6 TO 8

Preheat the oven to 350°F.

Peel, pit, and slice **2½ pounds firm but ripe peaches**. In a bowl, toss the peaches with **½ cup of firmly packed light brown sugar, a pinch of salt, 1 tablespoon of chopped fresh thyme, ¼ cup of cornstarch**, and **2 tablespoons of fresh lemon juice**. Set aside.

In a food processor, pulse **½ cup of flour, ¾ cup of firmly packed light brown sugar, ½ teaspoon of ground cinnamon, ¼ teaspoon of ground cloves, a pinch of salt**, and **1 tablespoon of fresh thyme leaves**. Add **½ cup of cold butter** cut into pieces and pulse until the mixture clumps together. Fold in **1 cup of old-fashioned oats**.

Roll out the **pie dough** into a 12-inch round. Place the pie dough in a deep 9-inch pie plate, crimping the edges. Add the peaches in an even layer, then top with the crumble topping.

Bake the pie for 55 to 60 minutes, until the filling is bubbling and the crust is golden brown. If the topping begins to get too brown, tent with foil.

Let cool at room temperature for at least 2 hours, and preferably overnight, before serving.

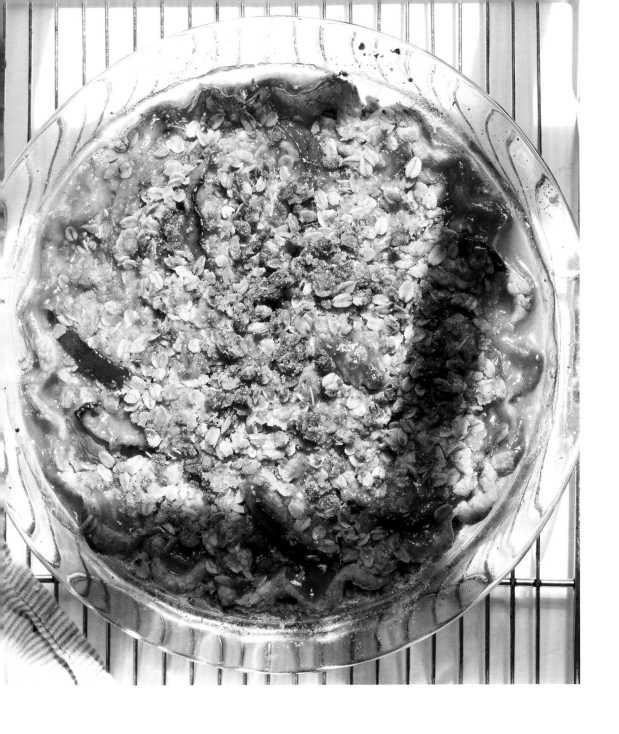

FLAVOR

GOLD

Cucumber Yogurt Sauce

Refreshing, Cooling, Bright

MAKES ABOUT 1½ CUPS

SHOPPING LIST

Cucumber	Lemon
Fresh mint or dill	Greek yogurt

Using a cheesecloth or sturdy paper towel, gently squeeze out water from **½ cup of freshly grated cucumber**. Combine in a large bowl with **1 cup of full-fat plain Greek yogurt**, **a large pinch of salt**, **a pinch of black pepper**, **1 tablespoon of coarsely chopped fresh mint or dill**, and **½ teaspoon of finely grated lemon zest**. Stir well and serve immediately.

TIPS If the cucumber is not squeezed, the sauce will be too watery. I like Greek yogurt because of its thickness, but you can use other types of yogurt; just make sure it is plain, unsweetened yogurt.

Garlic Confit

Tender, Sweet, Rich

MAKES ABOUT 2 CUPS

SHOPPING LIST

Olive oil	Garlic

Preheat the oven to 250°F.

Peel **3 heads of garlic** and arrange the cloves in a single layer in a small ovenproof roasting pan. Cover with **1½ cups of olive oil**.

Roast the garlic for 2 hours, or until tender. Store the garlic covered in its oil in the fridge for up to 1 week.

TIP Add this flavor gold anywhere that needs extra flavor: vegetables, pizza, toasted bread, or even on top of soups. Both the oil and the garlic can be used to add flavor.

Goes-with-Everything Herby Green Sauce

Herbaceous, Vibrant, Flavorful

MAKES ABOUT 1½ CUPS

SHOPPING LIST

Olive oil	Fresh soft herbs
Honey	Shallot
White wine vinegar	

In a food processor, combine **2 cups of coarsely chopped fresh soft herbs,** such as mint, parsley, dill, or cilantro; **1 minced shallot; 1 teaspoon of honey;** and **¼ cup of white wine vinegar**. Pulse until the mixture is chopped. Drizzle in **1 cup of olive oil** with the motor running and taste for **salt** and **pepper**. Store in the refrigerator for up to a week.

TIPS This is a great way to get rid of excess herbs before they go bad. Any type of herb or combination of herbs works—just make sure it is a soft herb like parsley, basil, mint, cilantro, or dill. This sauce goes really well with NY Strip Steak (page 186) or drizzled on Dukkah-Crusted Crispy Chicken Cutlet (page 152).

6-Minute Jammy Egg

Rich, Soft, Gooey

MAKES 4 EGGS

SHOPPING LIST
Eggs

Bring a large pot of water to a boil over high heat. Carefully lower **4 eggs** into the water, lower the heat until it is just barely boiling, and cook for 6 minutes.

Plunge the eggs into an ice bath. Let sit for 2 minutes, or until cool enough to handle. Carefully crack the egg shells on the counter, then return the eggs with cracked shells to the ice bath for another 5 minutes.

Peel the eggs and store in the fridge for up to 5 days.

TIP Don't let the eggs cool completely before trying to peel. I feel this helps make peeling a little easier.

Pistachio and Peanut Dukkah

Bright, Warming, Salty

MAKES ABOUT ½ CUP

SHOPPING LIST

Coriander seeds
Cumin seeds
Fennel seeds

Sesame seeds
Roasted pistachios
Roasted peanuts

In a small skillet, combine **2 tablespoons of coriander seeds**, **1 tablespoon of cumin seeds**, and **½ teaspoon of fennel seeds**. Toast over low heat until fragrant, 2 to 3 minutes. Combine in a blender or food processor with **2 tablespoons of roasted pistachios**, **1 tablespoon of roasted peanuts**, and **1 teaspoon of salt**. Blend on high until the mixture is ground. Fold in **1 tablespoon of sesame seeds**. Store dukkah at room temperature in an airtight container for up to 2 months.

TIP Dukkah can be used anywhere extra flavor is needed: on top of a salad, a grain bowl, or even sprinkled over grilled chicken.

Pickled Red Onions

Acidic, Bright, Loud

MAKES ABOUT 1 PINT

SHOPPING LIST

Sugar
Black peppercorns
Bay leaf

Apple cider vinegar
Red onion
Star anise (optional)

In a saucepan, bring **1 cup of apple cider vinegar**, **1 cup of water**, **2 teaspoons of sugar**, **2 teaspoons of salt**, **1 bay leaf**, **1 teaspoon whole black peppercorns**, and **1 star anise** (optional) to a boil.

Put **1 thinly sliced red onion** in mason jar or other heatproof container. Pour the pickling liquid over the onion, making sure all of the onion is covered with the liquid. Let it cool on≈the counter for 30 minutes, then cover and refrigerate. Once the onions begin to turn pink, after about 30 minutes, they are ready to eat. Keep stored in the refrigerator for up to 2 weeks.

TIP The thinner the onion is sliced, the faster it will pickle.

Preserved Lemons

Citrusy, Salty, Acidic

MAKES 1 PINT

SHOPPING LIST
Red pepper flakes Lemons
Cinnamon stick

Wash **3 lemons** well, then cut into quarters. Rub **salt** all over the lemon wedges.

Fill the bottom of a 1-pint mason jar with about **1 inch of salt**. Add a third of the wedges, then cover with **more salt**. Using a wooden spoon, press the lemon wedges to squeeze out the juice. Repeat twice with the remaining lemon wedges. Add **1 pinch of red pepper flakes** and **1 cinnamon stick**.

Squeeze 2 additional lemons and pour the juice over the lemons in salt. Cover the jar and shake a couple of times, adding more juice if necessary to cover the lemons completely with lemon juice. Place the preserved lemons in the fridge for 3 weeks to allow them to cure and preserve, shaking every once in a while.

When ready to use, rinse off a piece of a lemon. Discard the pulp but keep the rind. Slice it and add it to salads, pasta, chicken, or anything that needs an extra hit of salt and acid.

Preserved lemons will keep for up to a year in the fridge.

TIP The key to preserved lemons is making sure that they are covered with the salt and liquid while they are curing. This will ensure they become preserved and do not spoil.

Romesco Sauce

Smoky, Bright, Warm

MAKES 2 CUPS

SHOPPING LIST

Roasted hazelnuts Tomato paste

Smoked paprika Red wine vinegar

Olive oil Fresh parsley

Roasted red bell Garlic
peppers

Drain **1 (12-ounce) jar of roasted red bell peppers** and combine in a food processor with **1 clove of garlic**, **¾ cup of roasted and skinned hazelnuts**, **2 teaspoons of tomato paste**, **¼ cup of coarsely chopped fresh parsley leaves**, **2 tablespoons of red wine vinegar**, **2 teaspoons of smoked paprika**, and **a large pinch of salt**. Pulse until combined. Drizzle in **½ cup of olive oil** and pulse until you have the desired consistency. Serve immediately or store in a covered container in the refrigerator for up to 2 weeks.

TIP Swap in other nuts for the hazelnuts; almonds are great, as are walnuts.

Scallion Oil

Spicy, Grassy, Pungent

MAKES 1 CUP

SHOPPING LIST

Red pepper flakes Scallions

Neutral oil

Heat **1 cup of neutral oil** in a saucepan over medium heat until barely simmering. Carefully add **1 bunch of sliced scallions** and **a pinch of red pepper flakes** and sauté for 1 to 2 minutes, until the scallions are golden. Remove from the heat and let the mixture cool. Store in the refrigerator for up to 3 weeks.

TIPS Only slice the white and light green parts of the scallion. Drizzle this sauce on the Savory Porridge Bowl (page 17) or wherever you need a bit of extra flavor.

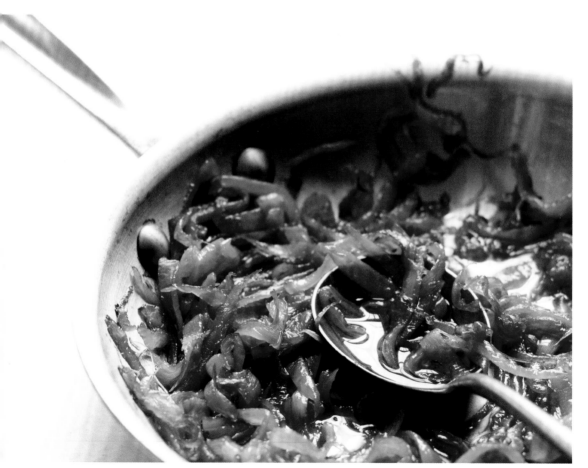

Tomato Vinaigrette

Acidic, Savory, Fresh

MAKES ABOUT 2 CUPS

SHOPPING LIST

Olive oil	Cherry tomatoes
Red wine vinegar	Chives
Shallot	

Warm **3 tablespoons of olive oil** in a skillet over medium heat. Add **1 minced shallot** and sauté for 30 seconds, or until soft and translucent. Cut in half **1 pint of cherry tomatoes** and add to the skillet with **a pinch of salt** and **a pinch of black pepper.** Cook for 4 to 6 minutes, until the tomatoes are soft. Add **1 tablespoon of red wine vinegar** and **1 bunch of chopped chives**. Serve immediately or store in a covered container in the fridge for up to 1 week.

TIP This sauce is delicious tossed with pasta, served alongside warm bread as a dipping sauce, or even as a topping on grilled meats.

Caramelized Onions

Savory, Rich, Creamy

MAKES ABOUT 2 CUPS

SHOPPING LIST

Olive oil	Onions

In a large skillet, combine **2 thinly sliced onions, 3 tablespoons of olive oil,** and **a large pinch of salt**. Cook over medium-low heat for 45 to 55 minutes, stirring occasionally, until the onions are soft and golden brown. Store in an airtight container in the refrigerator for up to a week.

TIP Be careful not to have the heat too high under the onions or they will burn. If they do, add about ½ cup water to the onions and continue cooking. The water will help dilute the burned parts of the onion and maintain the even golden appearance while it evaporates.

About the Author

Amanda Frederickson is a professional cook, cookbook author, and recipe developer living in Nashville, Tennessee, with her husband, Luke, and daughter, Olivia.

Amanda attended San Francisco Cooking School, and after a stage at one of San Francisco's Michelin-starred restaurants, she landed in the Williams-Sonoma Test Kitchen. For almost two and a half years, Amanda wrote recipes and tested products in the Test Kitchen, all with the sole purpose of creating delicious food for the home cook. In addition, she cowrote eleven cookbooks under the Test Kitchen title sold in stores and online at Williams-Sonoma, as well as authored *The Staub Cookbook* (Ten Speed Press), which was released in September 2018. She is opening her first restaurant in spring 2020, in Nashville, Tennessee.

Acknowledgments

Thank you to my editor, Kelly Snowden, for always being my champion and believing in my food and style of cooking. You have been such a bright light for me as I try and find my way in this crazy freelance world. Thank you to the rest of the team at Ten Speed Press: designer Isabelle Gioffredi, creative director Emma Campion, managing editor Lisa Regul, and production manager Dan Myers. Without your help and talents, none of this would be possible.

Thank you to Nicole Tourtelot, my agent, for believing in my vision and especially *Fridge Foraging*. Even though this book isn't the exact one we pitched, thank you for being my sounding board along the way.

Judy Kim, where would I be without your help! You came in at the right time and helped me bring these recipes to life. Your styling and overall creative advice was invaluable.

Cody Woodside, thank you for jumping into my crazy life. You are a superstar of a food styling assistant.

To Jodi Liano, thank you for helping to convince me to quit my 9-to-5 job and go to cooking school. It was one of the best decisions in my life and I will forever be indebted to you and your team at San Francisco Cooking School.

To my testers, Siobhan Krishnaswamy, Mia Wasserman, and McKenzie Mitchell, thank you for cooking your way through my recipes and for all of your feedback.

To Dad, Ashley, Claudia, and JE, I love you all and feel so blessed to have you as my family and in my corner. To my girlfriends, thank you for always supporting my crazy dreams and allowing me to simply be myself around you all.

To Chumley, you are the best bad dog on the planet and thanks for always being my constant companion in the kitchen while I cook.

Thank you to all the supportive brands I have been able to work closely with: Staub, Cosentino, and BlueStar.

Thank you Ashtin Paige for the sweet pictures in here of me and my family.

Index

All rights reserved.Published in the United States by Ten Speed Press,
 an imprint of Random House, a division of Penguin Random House LLC, New York.
 www.tenspeed.com

Ten Speed Press and the Ten Speed Press colophon are registered trademarks
 of Penguin Random House LLC.

Library of Congress Cataloging-in-Publication Data
Names: Frederickson, Amanda, author.
Title: Simple beautiful food : recipes and riffs for everyday cooking / Amanda Frederickson.
Description: Emeryville, California : Ten Speed Press, 2020. | Includes bibliographical
 references and index. Identifiers: LCCN 2019030974 | ISBN 9781984857347 (hardcover) |
 ISBN 9781984857354 (epub)
Subjects: LCSH: Cooking, American. | Quick and easy cooking. | LCGFT: Cookbooks.
Classification: LCC TX715 .F8514 2020 | DDC 641.5/12—dc23
LC record available at https://lccn.loc.gov/2019030974

Hardcover ISBN: 978-1-9848-5734-7
eBook ISBN: 978-1-9848-5735-4

Printed in China

Design by Isabelle Gioffredi
Food and prop styling by Judy Kim
Props by Charlotte Autry

10 9 8 7 6 5 4 3 2 1

First Edition